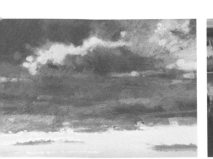
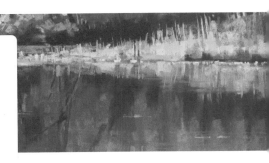

PAINTING BRILLIANT SKIES AND WATER IN PASTEL

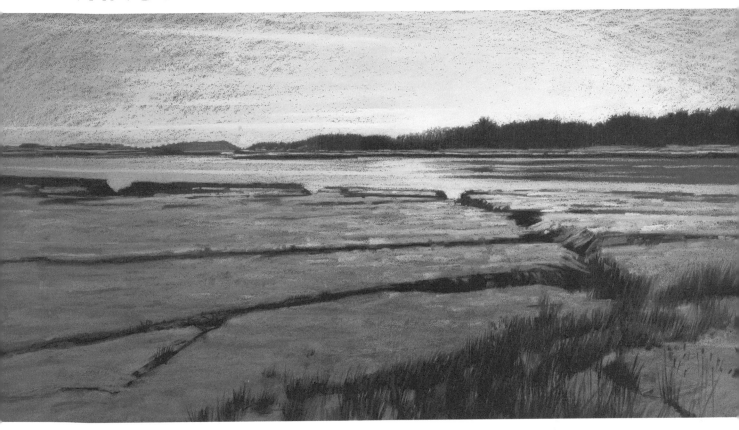

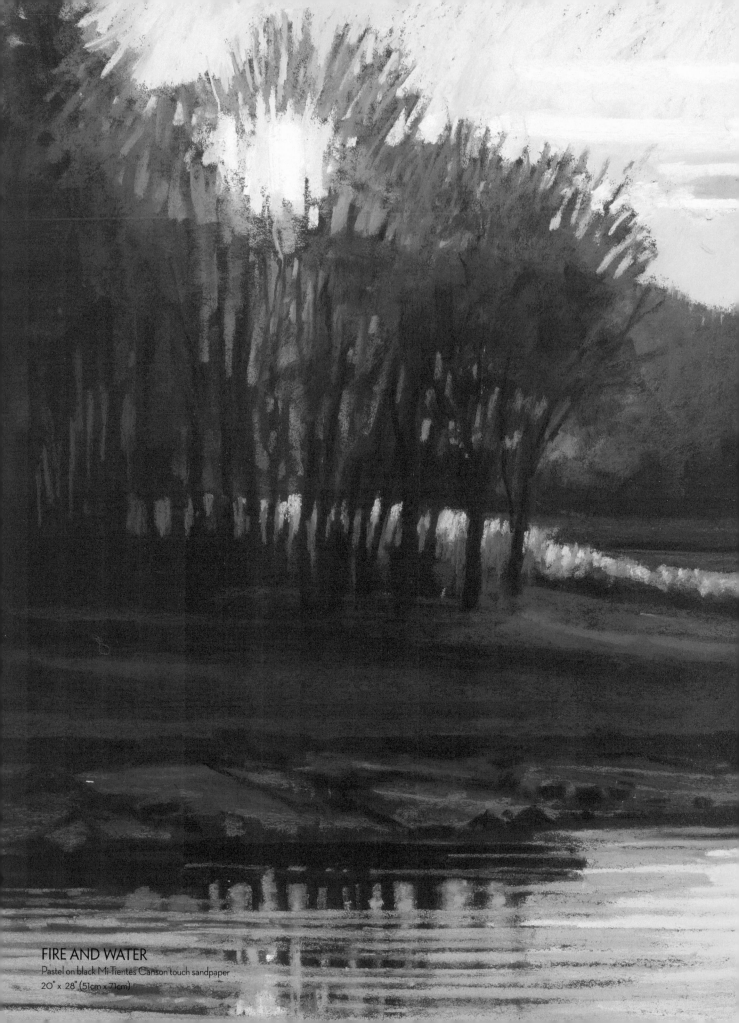

FIRE AND WATER
Pastel on black Mi-Tientes Canson touch sandpaper
20" x 28" (51cm x 71cm)

PAINTING BRILLIANT SKIES
AND WATER IN PASTEL

LIZ HAYWOOD-SULLIVAN

NORTH LIGHT BOOKS

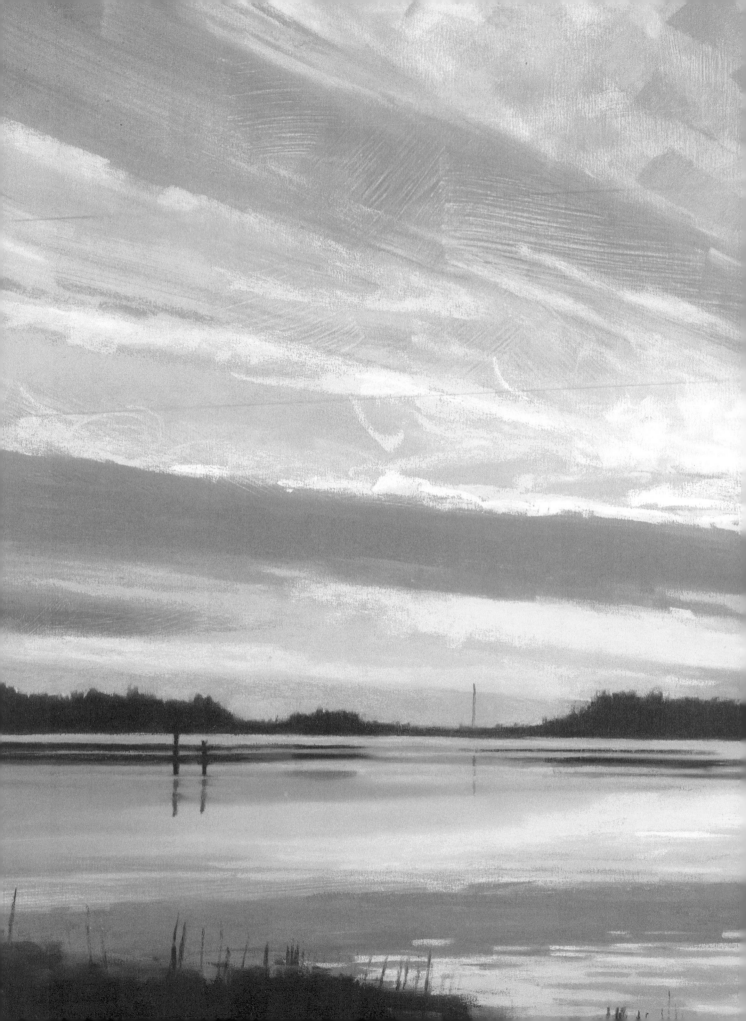

CONTENTS

DEPARTING DAY
Pastel on UART #500 sanded pastel paper
17" x 27" (43cm x 68cm)

Sky and water. Both are critical elements that artists have endeavored through the ages to faithfully reproduce in their landscapes. These two elements have extensive and varied characteristics and, as such, they are the exclusive subject of this book.

The sky is the most emotional aspect of a landscape. Even a small sliver of sky can indicate the nature of the weather or suggest the time of day, establishing the mood of a painting. Observing the countenance of the sky is like reading the expression on a face: A blue sky carries an optimistic outlook and dark-bottomed clouds signify foreboding and impending change.

Water enlivens a painting by bringing life and movement to the landscape with its currents, flowing lines, atmosphere, dancing light and fascinating reflections.

The sky has beckoned to me since I was a child watching the change of seasons through the character of the clouds passing above. Painting the sky was my first love, a subject that continuously showed up in my work. I thought it was my favorite subject until I noticed that, more subtly, water was often in my compositions as well.

This book explores the character of my two favorite subjects. It is illustrated with finished art as well as many step-by-step demonstrations that share my process, peeling away layer by layer how I produce a painting. A bit of science is included because I think you are a better artist when you understand what you are painting. If you can get into the character of your subject and become one with it, then that understanding will guide your hand, imbuing your painting with that innate essence we all strive to capture.

INTRODUCTION

Enjoy learning a range of techniques, from how to paint a clear sky to the character of clouds and how to apply them over the sky. Learn to see the different layers of transparency in water and the nature of reflections. You'll also find examples of ways to do things and what not to do. If there is one concept that I wish you take away from this book, it is this—as important as it is to technically understand your subject, your powers of observation are to be trusted. You need to paint what you see, not what you think. Enjoy!

JUBILEE ➤
Pastel on Wallis sanded paper
24" x 18" (61cm x 46cm)

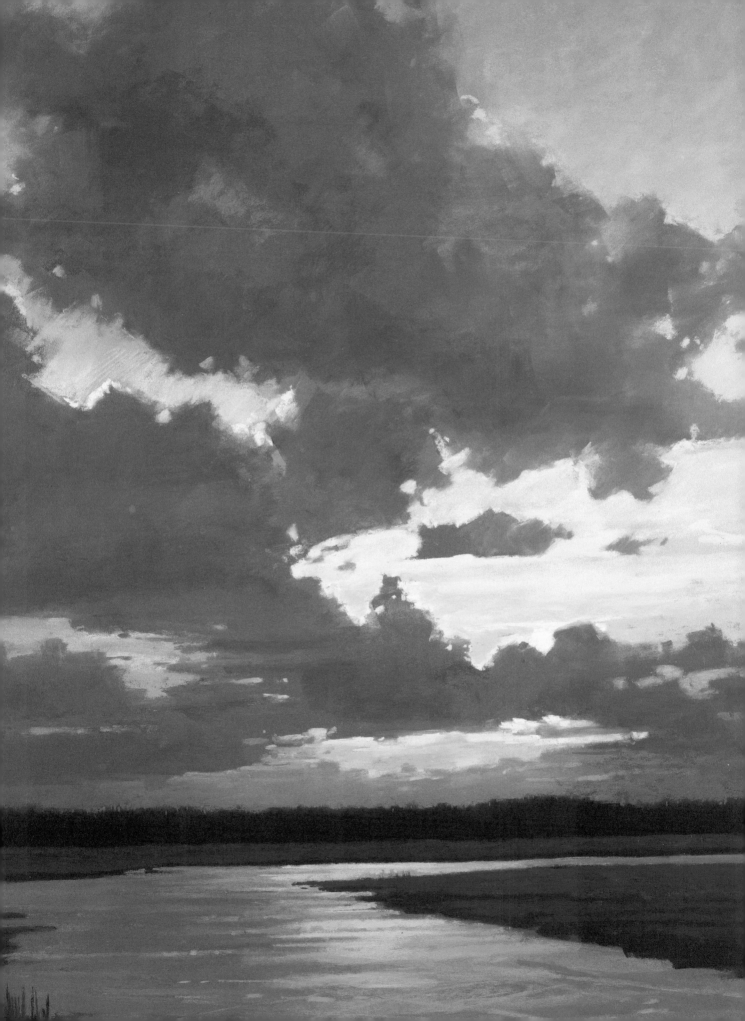

THE IMPORTANCE OF SKY IN THE LANDSCAPE

Since the sky is the source of light in a landscape painting, it is critical to spend time observing it, understanding it and learning how to get it right. We can't paint without light because it creates the very forms we paint. The sky not only gives us quality of light (bright, muted), quantity of light (dusk, daytime, night), but it also gives us location of light (direct, cast, reflected) and angle of light (time of day and year).

FOCUSED OBSERVATION

Learning about the sky doesn't mean just taking pictures of a riveting sunset to paint at a later date. To really learn about the sky, you need to spend quality time looking at it. Observe it from different points of view. Try looking at the sky and landscape by comparing them as shapes of value, or look at clouds by seeing the negative space around them as opposed to the shapes of the clouds themselves. Look at the relationship between sky and treetops when you have the sun behind you, and then turn around and see the difference in this value relationship when the scene is backlit. Observe the color change from the blue sky above you to the sky at the horizon. Does the value change as you turn around and the sun is in different locations? Also, really slow down and look at clouds. Bring out your sketchbook and try to capture the gesture of the clouds moving through the sky. Learn how to grab their movement in a few strokes and then slow down to draw some details of the value relationships and forms in an individual cloud.

A REVEALING EXERCISE

A great way to learn about light and color is to choose a color in the environment and ask yourself, "If I were to draw this, which paint would I pick?" I started doing this as a child when I was fascinated with the color of snow in waning light (it was purple!) and I continue looking at light in the same way to this very day.

Do this with your plein air setup—not doing an actual painting, but just looking at a spot and then trying to match the color on a piece of paper. What you will find is that the values and colors you think you are seeing are often quite off! Colors are stronger and more vibrant, and there is more color in both lights and shadows.

THE BOTTOM LINE

The sky provides the setting for your painting. It provides the light for your subjects, it produces the mood, and gives you clues as to location, time of day and time of year. It can be the entire painting as in a depiction of a stunning sunset, or it can be a sliver of muted light poking through the trees. It can even be absent but still providing reflected light to illuminate the side of a house. The sky defines the shapes we paint and the values we struggle to capture.

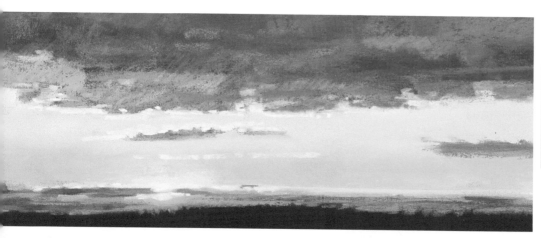

≪ **GOLDEN GLOW**
16" x 16" (41cm x 41cm)

ON A CLEAR DAY YOU CAN SEE FOR MILES… ≫
Pastel on UART #500 sanded pastel paper
40" x 27" (102cm x 69cm)

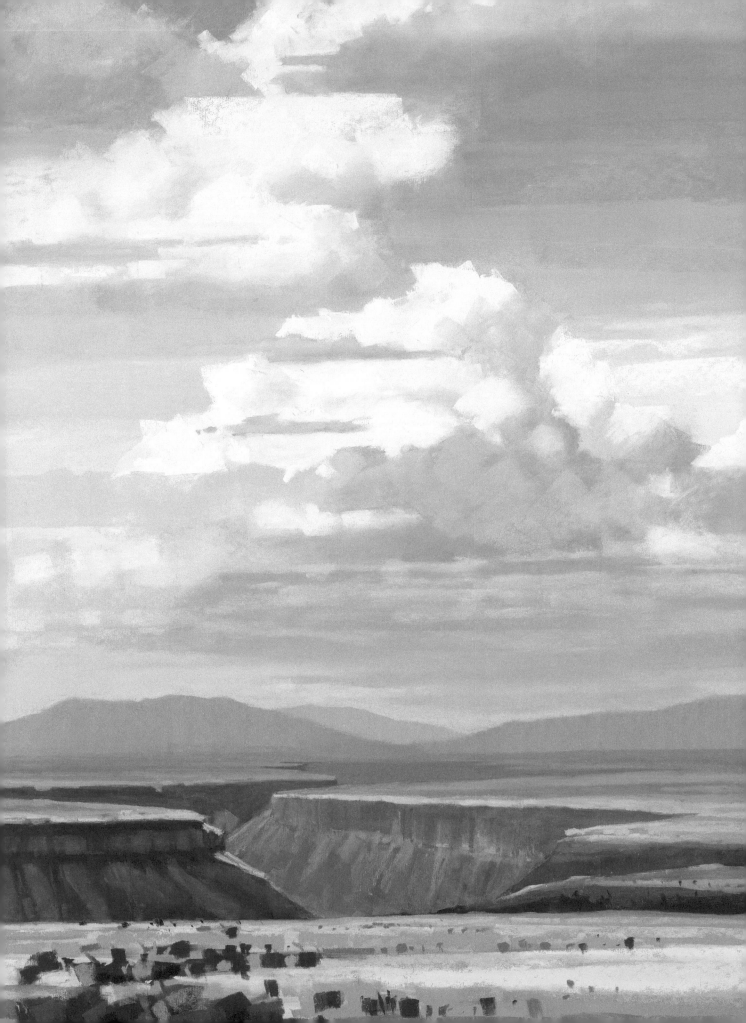

WHERE SKY AND LAND MEET

Nailing the value relationship where the sky and land touch is vital in a landscape painting. If this relationship is off, then the painting will never look right. The values of these two elements are the basis for all other value judgments you make throughout. It is therefore important to get these two values to work together from the very beginning of a painting. The easiest way to see these values is to squint!

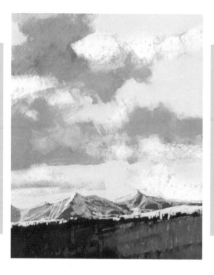 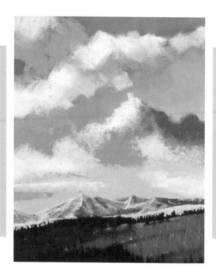 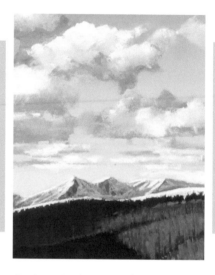

Wrong—Clouds Don't Recede

The value relationship where the sky and mountains touch is correct, but the sky stays the same value and color throughout, instead of transitioning to a darker value towards the top. Also, the clouds are pretty much the same size from top to bottom. As clouds recede, they should get smaller and flatter.

Wrong—Inconsistent Value Transition

Dark sky color is often the problem when using photographic reference. The sky becomes oversaturated. In this case, there is a good value transition, but the starting value where the sky and mountains meet is too dark. Also, notice the middle of the sky: The transition is not even from side to side. The sky is darker in the middle than at the right edge. When these common mistakes happen, the sense of light becomes confusing to the viewer.

Right—Good Value Transition, Good Color, Good Aerial Perspective

All elements come together in this painting. The color value of the sky where it meets the mountain is the same as in the first painting, but here it darkens evenly as it transitions upwards behind the clouds. And the clouds display proper aerial perspective, getting smaller and flattening out as they recede.

THE SKY SETS THE MOOD

The sky is a very powerful component of a landscape painting with its ability to manipulate your emotions. These two paintings exhibit two very different moods with the sky leading the way. The gray moody sky sets the tone for a misty, low contrast, contemplative painting. Whereas, in the second painting, the brilliant colors of daybreak and strong contrasts are full of optimism and energy as a new day emerges. What do you want your paintings to say?

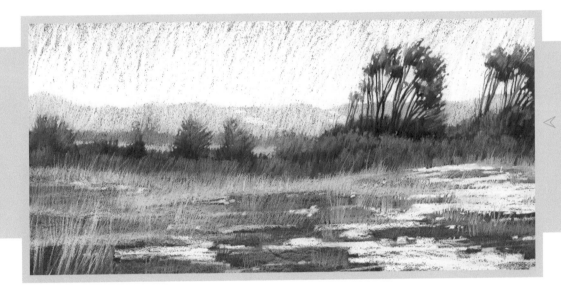

< WINDSWEPT
Pastel on black Canson paper
15" x 40" (38cm x 102cm)

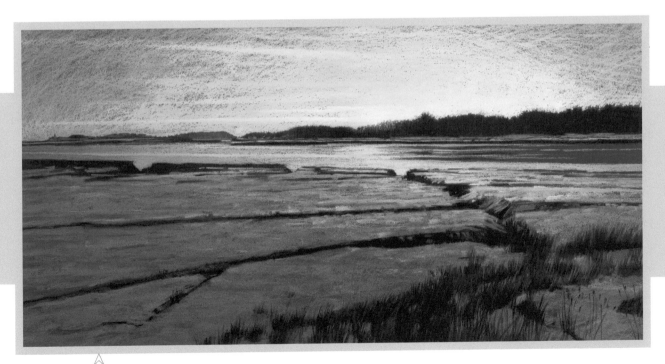

NORTH RIVER DAWNING
Pastel on black Canson paper
15" x 36" (38cm x 91cm)

THE IMPORTANCE OF WATER IN THE LANDSCAPE

After the sky, water is probably the most prolific element appearing in landscape paintings. Water provides a focal point, helps to indicate distance and can provide a dramatic backdrop for a stately sailboat, a walk on the beach or an impending storm. Like the sky, which it mirrors, water is very emotional. It gives clues to the weather by the nature of its color and whether the reflections are mirrored, choppy or almost nonexistent. You can feel the wind on your face and smell the salt of the sea when observing a painting of waves crashing on a beach! Come to think of it, an artist is probably the only soul who can harness the power of the sea. Interesting thought.

PAINTING AND OBSERVING WATER

One of the reasons artists paint water is for the pure joy of it. We are drawn to oceans, lakes, waterfalls, beaches and pools for our enjoyment and relaxation. Water in a painting captures these pleasant emotions and bring back happy memories. Water is soothing. Properly painted, you can almost hear the sound of it. As a result, painting scenes containing water can be very lucrative. I had a friend mention after an art fair that all people wanted to buy were her paintings of the beach and sailboats. She was happy to provide them!

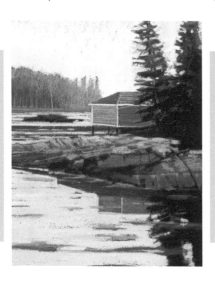

Wrong—Reflections Don't Degrade, Incorrect Angles

The reflections need to match up directly underneath their source and since water acts as a mirror, the reflections need to angle the opposite direction. The trees to the right continue incorrectly at the same angle. The building reflection doesn't line up directly underneath and is missing its roof. Lastly, the reflected trees don't exhibit any degrading of the image. Current lines would start to break up the image, and the trees would get lighter at their tops.

Wrong—Poor Aerial Perspective

Artists will often draw water in the distance going up at an angle as it moves away. Although you might perceive it this way, water actually stays flat. The aerial perspective is off. The current lines in the distant water are too thick, bringing the water closer instead of pushing it into the distance. The seaweed floating on the surface of the foreground is all the same thickness and too similar in size. This flattens the painting—progressively smaller and flatter shapes would create the sense of receding distance.

Right—Correct Aerial Perspective, Good Reflections and Image Evolution

The background water lays flat with progressively smaller lines moving into the distance. In the foreground, the reflections mirror their source properly. The reflection of the trees in the water displays proper degradation; it gets lighter and less distinct as it moves farther from the source. Thin current lines further break up the reflections and patches of seaweed floating on top of the water get smaller and flatter as they recede.

SERENITY ⟫
Pastel on Pastelmat
27" x 19" (69cm x 48cm)

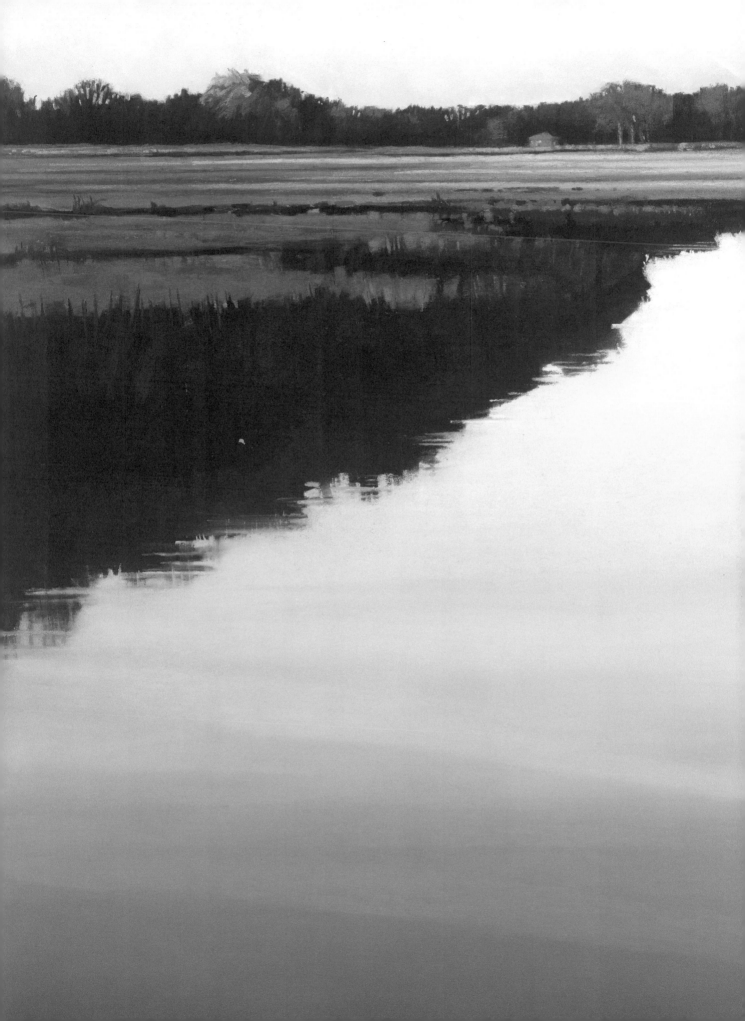

KALEIDOSCOPE ≫
Pastel on UART #500 artist sanded
pastel paper
16" x 40" (41cm x 102cm)

Paint What You See

You will see this sentiment repeated throughout this book. It is never more important than when observing water. We automatically think of water as blue, but that is far from the truth. Many factors influence the color of water—weather, depth, reflections, suspended sediment, minerals, time of day. And then add artistic license! We will explore some of these factors in depth and challenge your powers of observing water.

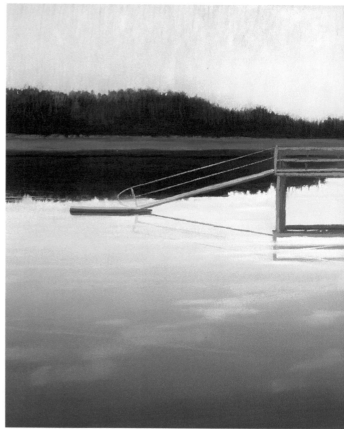

RIVERSIDE CALM ≫
Pastel on UART #500 artist sanded
pastel paper
15" x 40" (38cm x 102cm)

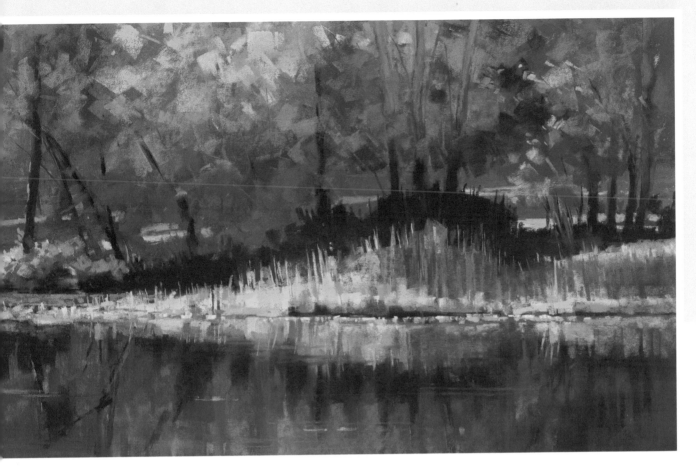

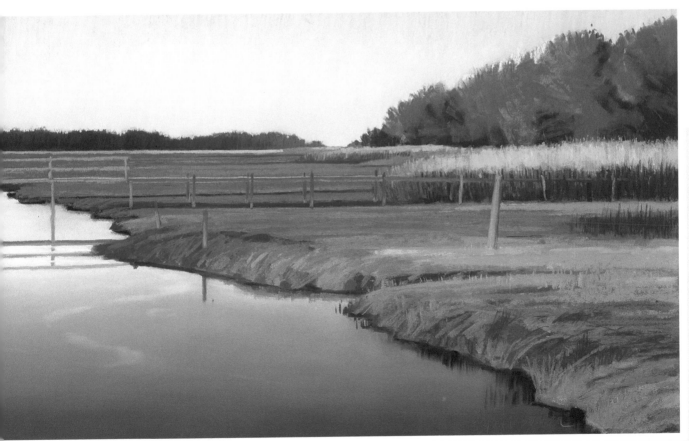

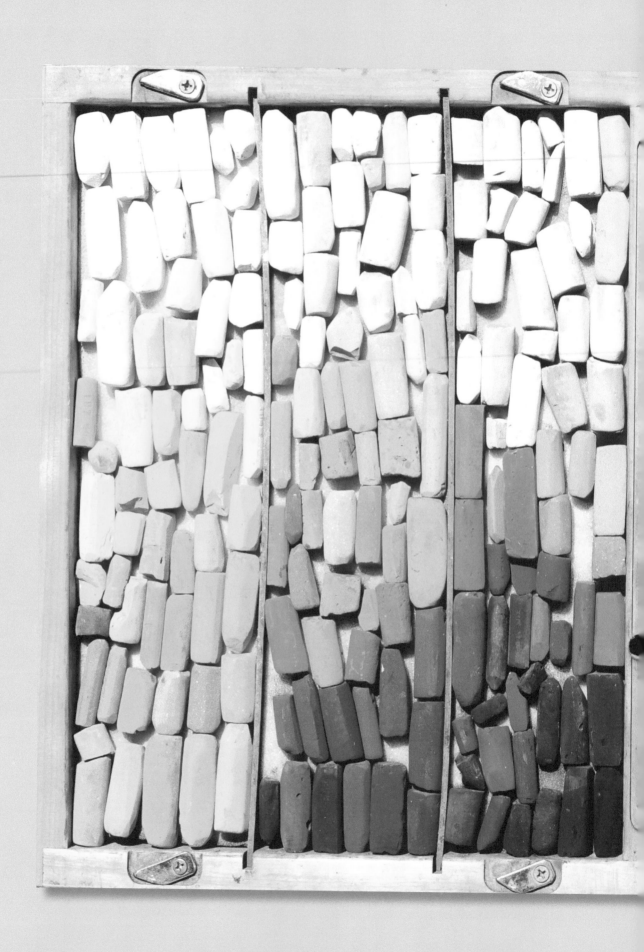

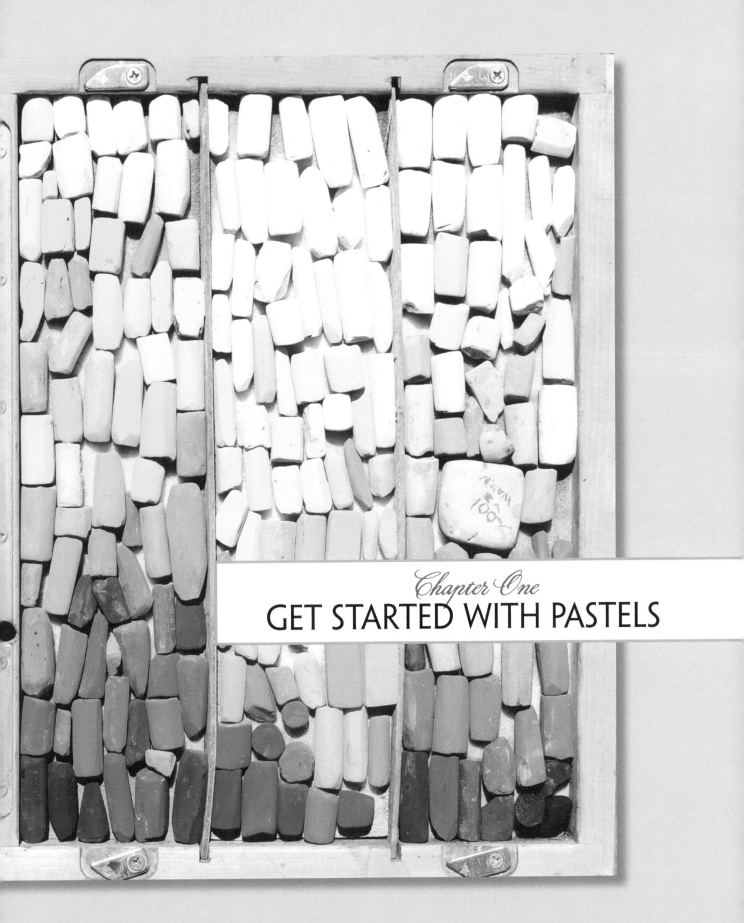

Chapter One
GET STARTED WITH PASTELS

THE PASTEL MEDIUM

When you pick up a stick of pastel, you're holding light and color in your fingertips. The tactile nature of this medium gives you immediate feedback and a direct connection to both pigment and paper. Pastels offer an artist an unlimited palette with few constraints as to application and expression. Indeed, there seem to be more individual styles than any other medium, in part because pastel can act as both drawing and painting. Best of all is the ability it gives the artist to paint light. The ideal method for painting in pastel is to start with your darks and then layer by layer develop the light, wrapping, draping and illuminating your subject just as it happens in reality.

In the past twenty years or so, there has been a renaissance in pastel. This new focus has been driven by advances in the actual medium and the substrates upon which pastels are painted, plus there are improved framing techniques to preserve the final art. Many new products were initially created by artists for themselves to fill a need for materials they were unable to find. At the same time, venerated lines of pastel used historically by artists such as the Impressionist artists Degas and Monet were being reinvigorated with availability to new markets, increased demand by artists, and a new generation of artistic leadership.

Pastels are created using the same pigments found in every medium. However, they are almost pure pigment with minimal binder and hence contain the highest concentration of pigment of any medium. Due to this renaissance, more artists and collectors than ever before are discovering pastel as a desirable painting medium. The resulting artworks rival other mediums in their competence, beauty, presence and permanence.

PURCHASING PASTELS

In an ideal world, we would be able to examine each stick of pastel before purchasing, especially the handmade pastels, where each stick seems to have unique characteristics. There are a few independently owned art supply stores that still have open stock where this is possible, but issues of breakage and concern about creation of pastel dust have limited the bigger chain stores from allowing this courtesy. Most handmade pastels are not even available through larger shops. Unless you are fortunate enough to live near a marvelous independent art store, you'll be ordering your supplies online. Thankfully the independents, as well as major chains, have robust online purchasing presence. This option has become better with manufacturers providing color swatches online, the ease of ordering and prompt shipping. Another option is to attend one of the media conventions, which include trade shows that manufacturers attend. Many are associated with different art organizations, and for pastelists, the highlight is the International Association of Pastel Societies convention that occurs every two years. Their trade show is aptly nicknamed the "Candy Store."

TYPES OF PASTELS

Pastels are broken down into three categories: hard, soft and oil. We will not be discussing oil pastels in this book; they act as a different medium. In the range between hard and soft pastels, there are many different variations. Through experience, you'll discover which pastels give you the look and feel that works best for you. I have noticed, when working with my students, that we are all drawn to the brilliant colors pastels embody so beautifully. New pastelists generally purchase a set of one brand and build off of that. However, you cannot paint with all bright colors. What is missing are the modifiers, the grays and colored neutrals that, when layered over those brights, can change temperature and modify value. Be sure your palette contains plenty of neutrals.

Harder pastels make a good drawing tool, to start a painting and to tighten up details at the end. Soft pastels lie down beautifully to create layers of color and go down well over harder pastels. Use soft pastels with a light touch to prevent the tooth of the paper from filling up.

Pastels also break down into either machine-made or handmade. Machine-made, extruded pastels are less expensive and tend to be harder, but are more consistent in color and shape, which artists like when reordering a favorite color. There are a number of handmade pastels to choose from that are generally

softer, with higher pigment concentrations and a larger color/ value selection. Experienced pastelists often use several brands, including both hard and soft pastels in their palettes. They often can't identify a particular pastel because as it gets used, the label has been removed and shape changed. A favorite response when a student inquires which pastel I am using is to hold it up and say, "This one."

STORING PASTELS

Storage depends upon on your working space. If you don't have a dedicated space for painting, then purchasing a pastel box where all of your pastels can be easily accessed in one portable unit is better than keeping them in separate boxes. If you attend classes, workshops or work *en plein air* (outside on location), then this will make your setup much easier. If you have a dedicated studio space, you'll need to find an efficient way to contain and display your pastels. We are always searching for the right color, and if it's hidden in a closed box, then we can't access it. One suggestion for limited space storage is to use an *étagère*, a ladder-like shelf that can display many boxes of pastels in a vertical space.

Be sure to have your pastels laid out in the same light as your working painting. If you have spillover light from a different source, like a window, it will affect the hue and value, and you will be frustrated by not being able to find the correct pastel.

SETTING UP YOUR PASTEL BOX

Arranging your palette by color and value will make it easier to search for specific colors. Start with the hues and transition from warm to cool colors. Since the neutrals are very important, give them their own hue section on one end. Then, arrange each hue section by value with the lightest values on one end to the darkest values on the other.

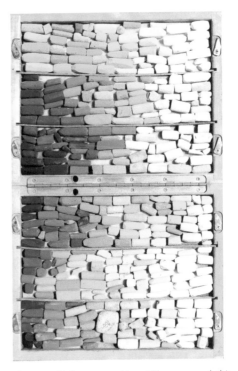

This is my Heilman pastel box. When opened, this palette measures 13" × 21" (33cm × 53cm) and has two covers that clip down to secure the pastels on each side. It folds in half to close for carrying.

Soft and hard pastels come in various shapes and sizes.

Painting or Drawing

There is a question as to whether pastels are paintings or drawings. Historically, pastel was considered a drawing medium since it was often used for preliminary sketches or field drawings for final paintings completed in oil. Although there are notable exceptions (such as in portraiture), not many artists created finished paintings in pastel, mostly due to the difficulty of preserving the artwork. Today, advances in the materials available have eliminated most of those concerns.

One way to consider whether a pastel is a painting has to do with how much paper is left visible. A painting has little paper showing through. Another way is how the pastel is applied. Drawings are often done with the artist holding the pastel like a pencil and drawing thinner lines with the tip of the pastel stick. A painting can be done with the artist breaking the stick to create different lengths, which are then applied by using the side of the pastel, creating visible stroke widths similar to those created by a paintbrush. Alternately, a pastel painting can be created with a finish so fine that specific marks are hard to discern and even the medium can be hard to determine.

CHOOSING YOUR PAINTING SURFACE

Selecting a surface to paint on is an endless source of conversation among pastel artists. Your surface choice affects the appearance and outcome of your painting as much as the pastels you choose. There are an ever-growing number of substrates available commercially, and you can make your own.

One important consideration for any artist working on paper is whether the paper is archival (acid-free). An archival surface not only ensures your work will survive for many years, but also makes it more desirable if you wish to sell. Paper made with cotton is more archival than paper made with wood pulp. Wood pulp contains more acid, which ages paper faster. Experiment with a variety of different surfaces and keep your eyes on the marketplace, as new and improved options are being developed on a regular basis.

PASTEL PAPERS

Choices include white, colored, smooth and textured papers of different weights. Some artists use traditional printmaking and drawing papers. Many of these are now available premounted on thicker ply paper or on boards to make them easier to handle and frame. Paper is not recommended for underpainting.

SANDED SURFACES

There are a number of sanded surfaces to choose from that have different colors, weights and grits. A sanded surface grabs hold of pastel better than paper and allows for more layers of applied color. Like paper, many of these sandpapers come premounted on boards. Almost all of them are excellent for underpainting.

MAKING YOUR OWN SURFACE

The benefits of making your own surface are only limited by your creativity. Starting with printmaking or drawing paper, board or other type of surface, apply a recipe of medium and grit. For unique effects, create distinctive surface patterns with a brush or other tool. The benefits include not being restricted to limited pastel paper sizes and the ability to create your own color and texture combinations. There are specific products you can buy that are pre-made for application to paper or board that will create a pastel surface or you can make your own. Search out other pastel artists, teachers, websites or blogs for information on their recipes—artists are usually happy to share! Even if you are pleased with commercially available papers, every now and then it's a good idea to spend some time experimenting with making your own surface. You never know if it will take your painting in a new direction.

MOUNTED BOARDS

Premounted paper on boards can be purchased, or you can ask a framer to do it for you. You can also mount your own paper using a dry mount press (which is a heat process) and archival adhesive, which will mitigate the transmission of acidic components. Do not use spray adhesives as these will not hold. Mounted paper on boards makes it very easy to move your art around with less chance of damaging the paper. Plus, a mounted painting is easier to frame with no need for an additional backing board and the insurance that your image will not warp in the frame. When painting with any liquid media on a mounted board, be sure to test it first. Any time two surfaces are joined together, there is always a risk that, when dampened, the two materials will not react compatibly and there could be separation or warping.

PAINTING WITH PASTELS

One of the advantages of working with pastel is that there are so many different ways to work with the medium. It is very expressive and can stand on its own, but also works well with other mediums. Experiment with pastel on top of a print, over an underpainting of watercolor, or with charcoal, pencil or oil.

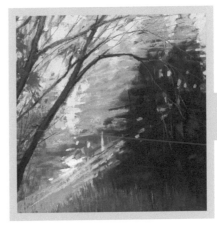

Apply the Technique

Use for crosshatching, or finished detail work such as tree branches, ship rigging, to sharpen architectural forms and for final accents that require a controlled hand.

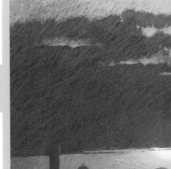

Working On Point

Hold the pastel like a pencil and work on the tip, making thin lines.

Blending

Blend sparingly. Try patting gently instead of smearing over an area to soften too much detail.

Apply the Technique

Blend for still water, especially when creating reflections; sky at the horizon; corners and bottom of paintings to reduce detail. It's also good for areas where you wish your painting to be restful and quiet.

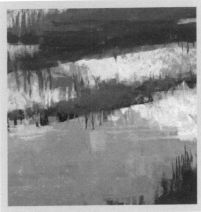

Apply the Technique

Build up areas where you wish the broad strokes to indicate information without getting into fussy detail, such as in painting foliage.

On the Side

Broad strokes are made by holding the pastel on its side. Good for blocking in your drawing in the first pass.

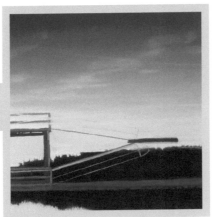

Hatching and Crosshatching

Crosshatching is when strokes are placed uniformly at angles to each other, or use random hatching, where the marks are not so uniform.

Apply the Technique

Build up a color and form you don't want to blend. This technique is also good for working on surfaces with a distinctive pattern or a rough tooth you wish to downplay.

Apply the Technique

Use for moving clouds or choppy water. This is so effective it can be used to create an entire painting.

Layering

Layer these broad strokes over each other with a light hand, so the color underneath is still visible and not blended.

Artists know today that they need to take responsibility for their health when working with any artistic medium. This is especially important when working in any space where your decisions can impact others, especially children. Organizations like ASTM International (see sidebar) act as watchdogs, but safe handling of art materials is an individual artist's obligation. The issue with pastel is the dust it creates. There are several measures you can take to prevent the transmission of this pastel dust.

STUDIO LOCATION
If possible, work in a space that is dedicated to your art. If you are unable to do this, then don't work where food is being prepared. Close a door or place a curtain across a doorway. When you clean up your studio, use brooms and wet cloths or mops to collect the dust. A vacuum will just stir up particles into the air. Of course, working outdoors is the easiest way to get around this.

AIR FILTER
I have a HEPA-rated air filter that sits on my easel and has revolutionized the cleanliness of my studio and whole house. When turned on, it creates a protective suction of air that draws the pastel dust down into the filter before it can reach my face as I am working. I also use this filter to clean my pastels. I turn it up high, take a pastel and brush it clean. I highly recommend a mechanized air filter system to keep your space clean. The peace of mind is worth the effort!

SKIN BARRIER
Pastel dust can have a cumulative corrosive effect on your hands, so I recommend either using medical gloves or a hand cream barrier. Some artists don't mind gloves although they will make your hands sweaty. Skin barrier creams are a good alternative. Just rub a bit of cream onto your hands and fingernails. Wash it off when you are done. Very effective.

AIR MASKS
If you don't have an air filter in your space and you find pastel dust is bothering you, research using an air mask or respirator. Be sure to use one that can screen out the fine particulates pastels create.

EASEL DUST CATCHER
A quick, easy, portable and inexpensive method to keep dust from escaping your easel is to get a roll of 2" (5cm) wide masking tape. Pull off a strip that is just wider that the painting on your easel and attach one long edge along the bottom back of your painting, pinching the sides of the tape together creating a trough in front to catch the dust, which is easily discarded when you are done. If you take classes, the facility will appreciate this courtesy.

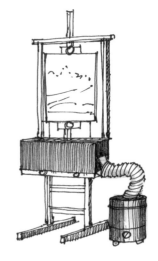

What is ASTM *and Why Should You Care?*

You have seen this label on your art materials, bu do you know what it is? A label containing the phrase "Conforms to ASTM D4236" means that any art material carrying this language has been tested. If it contains any component dangerous to your health, then by law, the manufacturer needs to disclose the hazardous component and give you directions as to its proper use on the label. The American Society for Testing and Materials (ASTM) was organized in 1898 and its work included developing standards for art materials. Today, ASTM International is one of the world's largest voluntary standards-writing organizations, creating standards for every product imaginable. ASTM Subcommittee D01.57 has worked to write voluntary standards for the health labeling, performance and quality of artist materials. Currently, this subcommittee is developing a lightfastness standard for the pastel medium, which will ensure that artists are aware which pastels will not fade with time and exposure to light. Next time you pick up art supplies, look for this label—and buyer beware if you can't find it!

Conforms to
ASTM D 4236

A traveling pastel artist is a work of art unto themselves. Each artist is unique, imaginative, often unorthodox (you're using that for what?!) and generally overburdened. Efforts to lighten our load are fruitless as we leave our homes and can't resist bringing along a "few" more colors, just in case.

To be effectively portable, the primary items to control are your pastels. This is when you need to investigate purchasing a travel box where all your pastels in separate containers can be consolidated. I recommend you find one that has compartments that mechanically close. Beware of Velcro closures. As they get dusty, they lose their effectiveness. To expand the number of colors in your box, break your pastels into half sticks. Trust me, they will be big enough and you will appreciate the extra colors.

WORKING EN PLEIN AIR

Having a portable setup will allow you to not only be mobile in your home, studio and class, but will give you the ability to work outside. Direct observation is an important discipline for any artist and, if possible, every landscape artist should spend time working outside. It is important to experience the limitations of working from photographic resources. See the variations of color in those dark shadows that just look black in a photo, and notice the subtle change of colors in what only appears to be a solid blue sky in a photo. The process of deciding what to paint and how to edit a scene when faced with an overwhelming landscape is another skill to be developed.

Having a setup that is easy to manipulate is helpful not only for setting up to catch light that is a moving subject, but also for the ability to quickly pull down if a thunderstorm is threatening.

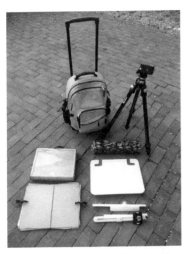

A Basic Portable Setup

This setup contains a backpack, a Heilman Box with approximately 250 half-stick pastels of various brands, a photo tripod with quick release mechanism, two pieces of cardboard with trimmed paper and glassine sandwiched in between, held closed by a rubber band and clips, my sketchbook, drawing utensils, a SunEden traveling adapter easel and clip-on artists shelf, bungee cord, small rug and the ubiquitous extra box of anticipated essential pastels. Everything but the tripod fits in a wheeled backpack.

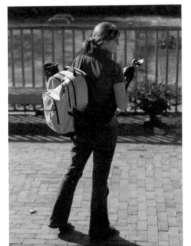

Lighten Your Load

Flying? Use a rolling backpack which fits comfortably on your back when going through the gate. The backpack fits easily into the overhead storage, and the tripod ships in your checked suitcase.

Pastels and Humidity

When summer arrives, bringing humid days, I find myself running the air conditioner in my studio, not for its cooling capabilities, but to dry out the air. Pastels are like sponges and absorb humidity readily, which can cause them to be more susceptible to breaking. It can also make the damp pigments behave more like an oil pastel, since the pigment particles cling to each other. A simple remedy for your travel box is to save up the little silica gel packets that come with shoes, medicines, etc. and place a few of them in your box where they will absorb extra moisture.

THE STRUCTURE OF A PAINTING

Artists talk about the terror of approaching a blank canvas or a blank sheet of paper and the immobility it can cause. One way to eliminate this stumbling block is to break the process of making a painting down into easily achieved steps. I call these steps "good bones" because they are the underlying structure upon which you build your painting. I use these steps with every painting I produce. Their foundation is good design and sound composition.

There is an order to doing these steps, which are described on the following pages:

1. Composition
2. Simplify Shapes
3. Value Study
4. Scale Up
5. Place on a Drawing

DRAW YOUR PAINTING FIRST
Start with thumbnail (small) sketches to break your painting subject down into simple shapes. Then use value studies to help you see the value relationships between these simple shapes by revealing the calligraphy, form and flow of your potential painting. If these initial studies don't produce the result you wish, then this may be as far as you go with this particular image, and you haven't spent a lot of time and expensive materials. I use a thin permanent marker in my sketchbooks for thumbnails because it doesn't smear, and then I use markers in various shades of gray, for my value studies.

SKETCHBOOK: THE FIRST PASS
Simplifying shapes and value studies are two important drawing steps. They are also the first passes you make in creating your painting and help familiarize you with the language, form and shape of your image. If, after drawing the image, you are still excited about doing the painting, then that enthusiasm will be transmitted to the final artwork. It is that energy that drives the creative effort and enriches your art with an intangible spark that speaks to viewers and makes time disappear when you are painting.

Treasure Trove

Sketchbooks are a critical tool for an artist. Use them for recording thoughts and ideas, and for thumbnail sketching to work out details and preliminary drawings.

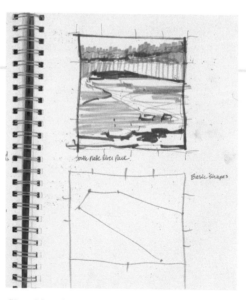

Sketchbook Work

Working on location with direct observation, this line drawing was generated to work out the basic shape of a river. Then I created a value study to determine the composition and value relationships of the scene before I committed to painting it.

FINDING YOUR COMPOSITION

Good composition is created through balance and harmony in the simple shapes, forms and lines. You can improve your paintings by becoming more aware of how important composition is to the success of your artwork. Instead of jumping directly into your final painting without any preparation, use the techniques described in this chapter to strengthen your design.

THE RULE OF THIRDS

The Rule of Thirds, also called the Golden Mean, is a mathematical concept. It describes how to divide a space into balanced and harmonious sections. In painting, you divide the image into three equal sections both horizontally and vertically. Where those lines intersect are the best locations to place a focal point, a so-called "sweet spot." Also, the location of those lines, at thirds, are good places to insert a primary object, such as a tree or building, or a horizon line. Notice that working with the rule of thirds discourages placement of shapes in the center or halfway mark. Thirds are good because they encourage unequal shapes, creating tension and movement. Centering and equal halves are static and unmoving.

Don't put an object in the center of the picture plane. This creates a static focal point and poor composition.

Do place an object at the sweet spot to give your composition a balanced focal point.

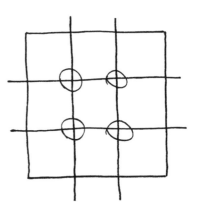

The Rule of Thirds

Don't place a horizon line at the halfway point, cutting your image into two equal pieces. Don't have a river or road lead to a vanishing point in the middle. Don't start a triangular shape at the center bottom.

Do place your horizon line at the one-third mark. Do aim a river or road at a sweet spot, creating a focal point with movement and balance. Offset the entry point of triangular shapes at the base of your painting.

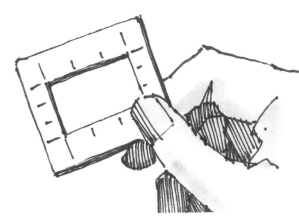

Use a cropping tool on location to find your composition. It puts a frame around your subject and cuts out extraneous information. Purchase one or make your own. My favorite make-it-yourself cropping tool is to use an empty slide holder with a piece of tape to change the shape.

SIMPLIFYING SHAPES

Look for a handful of dominant shapes. Squinting helps because sometimes very different objects will become one shape, especially if they are similar in value. The first shape delineation in a landscape is usually the horizon line. Subsequent shapes should be reduced to simple forms.

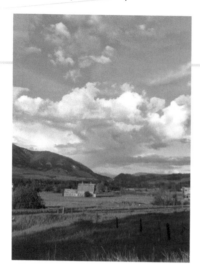

1 FIND YOUR SUBJECT

What is your painting about? What are you trying to say? In this case, the painting is about the magnificent cloud form. If the barn disappeared, it would not hurt the painting, so if it becomes distracting, it will be eliminated.

2 SIMPLIFY SHAPES

Sketch the first three shapes: the horizon line, the mountain form and the cloud. The cloud should be condensed into one simple shape.

Evaluate different croppings to determine the best composition. Keep in mind the Rule of Thirds for good balance and finding your focal point.

Evaluate the composition. The barn is too close to the center of the image. The cloud and the barn feel unbalanced with too much empty space above and below.

3 CROP THE IMAGE

Crop in tighter so the shapes fill the space better. However, the barn still seems too close to the middle, and the cloud feels like it is floating in the center of the image.

4 BALANCE THE FORMS

Crop to a square. Make the cloud hit the top edge of the frame and the barn anchor one of the sweet spots. Creating a pattern of zigzags makes for a lively and dynamic composition.

CREATING VALUE STUDIES

A value study for a painting can be done in conjunction with a thumbnail sketch, or if you wish, it could effectively serve as both. Use pencil or a similar drawing tool, or a variety of neutral-colored markers in different values to create a range of values. By assigning a value to each simplified shape, you will achieve a dimensional sketch which will act as an effective tool to evaluate the composition, rhythm and flow of your potential painting. Again, this is a first pass at whether the image has the right potential to become a painting.

By doing a value study prior to an underpainting, you will be making decisions that will make choosing values and colors for your underpainting easier, since the value study is done in shades of black and white and your underpainting generally adds the complicating factor of color.

Variations on the Value Study

Any of these value studies are valid. The advantage of the marker drawings is that they will not smudge in your sketchbook. Also, if you use a permanent marker, you can add watercolor to your thumbnails for color notes and the marker will not run.

Pencil drawing of simplified shapes.

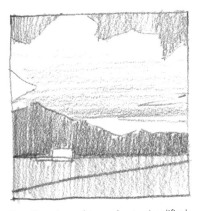

Pencil study applying value to simplified shapes.

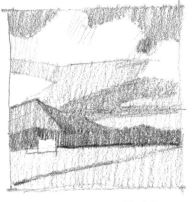

Pencil study breaking simplified shapes down into smaller value shapes.

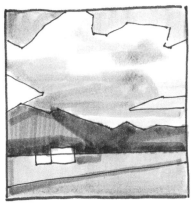

Marker study applying three Tombow markers over simplified shapes, breaking some shapes down into smaller forms.

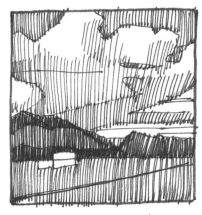

Using very thin permanent marker to create layers of line to build up values and shapes.

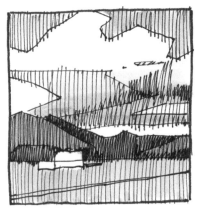

Value marker study with line overlay to break values into smaller shapes.

SCALING UP AND PUTTING IMAGE TO SURFACE

Be sure that the proportions of your image match your paper size. I cannot emphasize how important this is—otherwise your painting's proportions will be off, and you can find yourself well into the painting before realizing something is quite wrong. If your drawing is wrong, your painting is wrong.

PROPORTION

All you need is your cropped image, your painting surface and a straight edge. You don't need a ruler; use another piece of paper or the edge of a drawing pad. Place your cropped image in the upper left corner of your painting surface, making sure the top and left sides of the image line up exactly with the painting surface edges. Take the straight edge and line it up with the upper left corner and then the lower right corner of your cropped image. Now, extend that line all the way down to where it hits the right side of your paper. That is where you will crop. A simple solution!

LAY OUT YOUR DRAWING

You are ready to place your drawing on your paper or other painting surface. You have experienced the natural progression laid out in the previous steps: starting with thumbnails, using simplified shapes to clarify your composition, a value study and making sure your paper is the right size, all which lead up to this point. You are now familiar with the image and have worked out any potential structural problems and you have drawn the picture several times. Excited about your painting? It is time to dive in.

USE SIMPLIFIED SHAPES

All you need to put on the paper are your simplified shapes. No detail. Be sure both your and your paper have cropmarks for guidelines. Make sure you draw your image proportionately correct onto your surface. Again, slow down. This is especially important if you are on location and every time you look up you have to relocate your composition. Get these structural lines in the right places at the beginning, and you won't have to ever revisit them. Once the good bones are set, you can enjoy the process of laying the painting on top of them.

CHOOSE A BARELY THERE COLOR

Use a color that can be found in your painting and a value that is dark enough for you to see where you have placed your shapes, but be careful not to go too dark. This is especially critical in the sky, where the values tend to be lighter. Dark lines are hard to hide and can bleed into your final lighter colors.

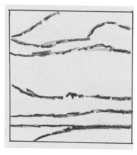

Don't: Too Dark and Fractured

Try to keep your lines simple and clean, not overworked.

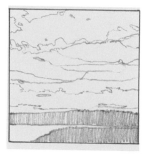

Don't: Too Much Detail

Don't spend time doing detail that will only get covered up.

Do: Good Layout Drawing

The linework is clean and light enough that it will blend into the final painting. Use crop marks.

UNDERPAINTING EXPOSED

Many artists find using underpainting is a beneficial and enjoyable way to start their pastel painting. It helps to establish mood and atmosphere—especially if you leave areas visible in the final painting. This technique allows you, in essence, to stain your paper in specific colors and shapes to create a base for your final art. Underpainting is also an effective and economical method because it allows you to evaluate your composition before you get too involved in your painting. Since it employs minimal materials, it also saves you money. I find myself using this technique more and more in my painting. The more experienced you get at it the more you can make the underpainting work for you. For instance, if you can establish the proper composition and values in the underpainting, the final painting flows much easier and comes up to finish faster, with less pastel used. The choice of color is secondary in importance to choosing the right value in an underpainting. I will show you different ways to approach your color choices later in this chapter.

CHOOSING YOUR MATERIALS

For the best results, you should use an artist-grade sandpaper that tolerates liquid and is light and neutral in color. This technique is not advisable for regular artist paper (non-sandpaper). Use pastel or watercolor to apply the color, although some artists use oil and acrylic paints, which require more care in application.

CHOOSING YOUR COLORS

This step is very important and worth slowing down to be careful in your choices. A value study can assist in helping you choose the proper value for each shape area. The color is not as important because if you choose the right value, you can modify the color once the underpainting has dried. Aim to select colors that, when dry, are the final value for a particular shape. If you aren't sure how a pastel will dry, do a test on another piece of paper.

Alcohol and Other Options

Isopropyl alcohol, or rubbing alcohol, can be found in local pharmacies or grocery stores. Don't use ethyl alcohol, also labeled as rubbing alcohol, since it contains acetone, which is not good to breathe or to get on your skin.

You cannot fly with alcohol, so if you find yourself away from your studio, in a pinch you can use vodka and water is always a good substitute. In desert climates I use water, because it dries quickly and alcohol dries too fast. Other good choices are turpenoid and mineral spirits. Try different options to find the one that suits you best.

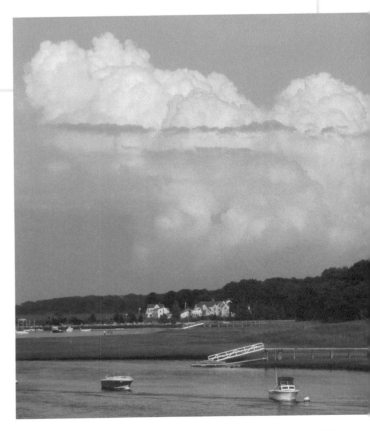

UNDERPAINTING

This demonstration will take you through all the steps I have described earlier, starting with thumbnails and value studies, to a detailed description of an underpainting, through to the final painting. For this demonstration, I will be using pastel with isopropyl alcohol to wash it down.

1 CROP YOUR IMAGE AND THUMBNAIL

Place cropmarks on your reference image, check that your paper size is the same proportion, and do your thumbnail sketch breaking the image down into a few basic shapes.

Materials

PAPER
12" x 12" (31cm x 31cm) UART #500 artist grade sanded pastel paper

Sketchbook with white paper

DRAWING
Black fine line marker or drawing pencil

PASTELS
Various manufacturers, texture medium hard to very soft

Light value: cream white, gray, blue-gray, peach, flesh, orange, yellow ochre, cobalt blue, ultramarine blue, turquoise blue, warm purple, yellow-green

Medium value: warm purple, gray blue-green, grass green, cobalt blue, ultramarine blue, turquoise blue, blue-gray, orange, yellow ochre

Dark value: burgundy, warm green

OTHER
Alcohol

Brush

2 CREATE YOUR VALUE STUDY

Now do a value study in either line or value markers. This is your first pass at familiarizing yourself with the values in the painting.

3 TRANSFER TO SANDPAPER

Using your thumbnail as reference, transfer basic shapes to your paper using a simple line drawing. Use one of your light value harder pastels to do the drawing.

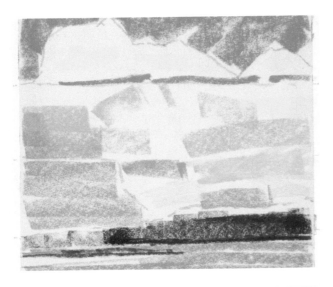

4 CHOOSE UNDERPAINTING COLORS

Choose colors that can peek through in the final painting. When a painting is predominantly cool, choose warm colors for the underpainting. For the darkest value in the tree line, use a dark burgundy, a midvalue yellow ochre for the foreground grass and for the water and clouds, medium to light value warm purples. When you are applying color to your paper, block in color shapes using the side of your pastel. Stay away from working with the tip. Also, do not put down too much pastel since it will start to fill up the tooth of the paper—a little goes a long way!

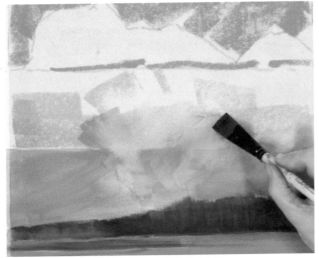

5 WASH DOWN WITH ALCOHOL

Put an small amount of alcohol in a clean container. Use a clean brush to start washing down the pastel. Wash down the dark shape first, rinsing your brush in the alcohol thoroughly before moving on to the next shape and its color. In the cloud area, apply minimal pastel. Use the alcohol to create a wash you can move around and paint with, similar to watercolor.

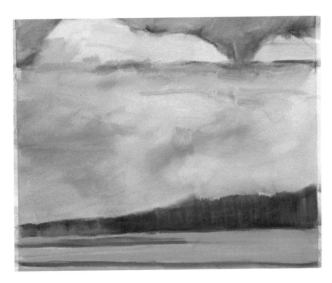

6 EVALUATE YOUR COMPOSITION

As your painting dries, now is the best time to evaluate your composition and drawing for any flaws that need to be corrected. A few corrections, washed down again, are easy to do at this point. Use a mirror to get a fresh look—seeing it in reverse allows the flaws to pop out as if you were seeing your painting for the first time.

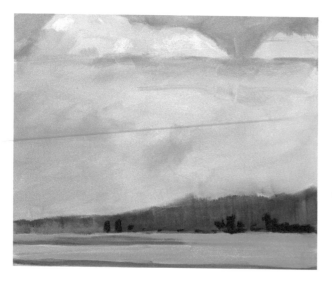

7 ESTABLISH EXTREMES OF VALUE RANGE

After the painting dries, use your first pastel marks to establish the extremes in the value range. By locating your darkest dark and lightest light, you give yourself the value parameters for this particular painting. Place a dark value green at the base of the tree line and make a few cedars a bit further to the left. Then, touch a warm, light value cream white to the top of the clouds, where the light strikes them.

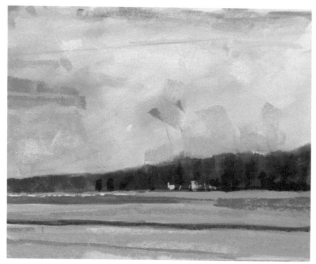

8 SELECT YOUR PALETTE

Select colors to modify the values of the underpainting. Use medium and dark value warm greens for the tree line and a midvalue gray blue-green for the distant treeline. Choose a range of warm greens for the grasses, from bright, light yellow-green to midvalue grass green. Use a medium to light value orange and yellow ochre in this area as well.

For the sky and water, use a range of medium to light value turquoise blue, cobalt blue, ultramarine blue and blue-grays.

Brushstrokes

When washing in the pastel, you can use brushstrokes to help develop your painting. Remember that some of the underpainted areas will show through in the final painting. And depending upon how heavy your pastel application has been, you can sometimes get ridges in your underpainting similar to what gesso looks like when applied with a brush. I suggest your brushstrokes follow the direction of the element you are painting. In this example, the grass strokes are horizontal, the tree strokes run vertical and the cloud strokes go every which way.

Download bonus materials at artistsnetwork.com/pastel-skies-water

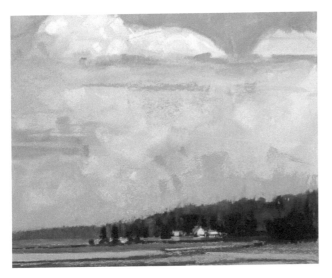

9 WORK OVER ENTIRE PAINTING

Set the greens down on the tree line and grass areas. Indicate the buildings with spots of light cream, light peach and light gray—no white here, which would attract the eye too much.

Now work on the sky. First, develop the transition of value from the lighter horizon to the top of the sky, where it gets darker. You can achieve this by layering different blues of the same value on top of each other, working from light to dark and carefully scumbling the transition from lighter to darker value. Working with the side of your pastel, soften some of the lower cloud edges.

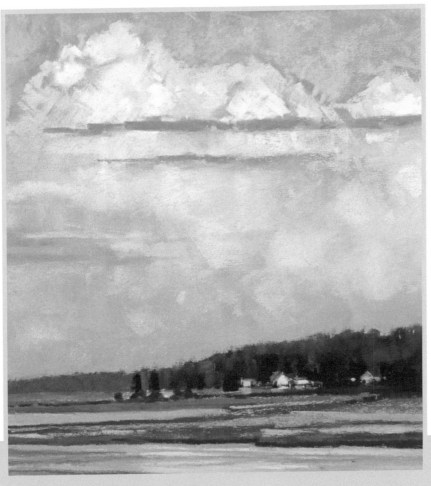

10 FINISH UP

Develop your lightest cream white, light peach and light flesh tone in the upper areas of the cloud. For the water, use the same colors as the sky, remembering that water is a reflective surface and will catch the light from the clouds. Make sure the shapes mirror each other. Let some purple underpainting show through, giving some depth and interest to the cloud. Do not overwork it. Too much detail in the base to middle of the cloud will distract your eye. This painting is all about the majesty and power of this amazing cloud; all other elements are supporting players.

DAMON'S POINT CLOUDSCAPE
Soft pastel on UART #500 artist-grade sanded pastel paper
12" x 12" (31cm x 31cm)

CHOOSING UNDERPAINTING COLORS

There are so many things to think about when it comes to choosing the colors for an underpainting that it can be daunting. You are using an underpainting to establish the composition, the value relationships between different shapes and to provide a color base for your final painting. There's a lot to remember, but after you have done several underpaintings, it will become second nature to you.

Here are three color options and the rationale for using each one. Find a color wheel to assist you in seeing these color relationships.

MONOCHROMATIC

The easiest method of color underpainting is to choose one color. This is good for moody paintings, atmospheric effects (fog, heavy humidity, rain, snow), paintings with a narrow value range and for general use. Try doing the same painting using different monochromatic underpaintings to see how they affect the mood of a painting.

COMPLEMENTARY COLORS

Complementary colors are opposite each other on the color wheel. This method is a way to add more color to your underpainting than in the monochromatic method, and it is still easy to figure out, especially if you have a color wheel handy.

Complementary colors are good for bright colorful scenes, sunlit scenes and anything with a lot of greens, but not great for predominantly sky scenes.

Try leaving a lot of the underpainting showing through for a looser, more Impressionist style.

ANALAGOUS COLORS

These colors are direct neighbors to each other on the color wheel. The analogous colors for blue are purple and turquoise.

This method is good for giving dimension to skies and clouds, or just about any scene. Try to nail the value so your painting is partly done in the underpainting!

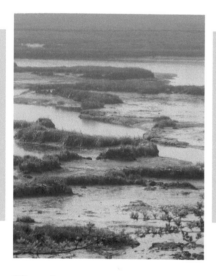

Monochromatic

In this case, I am using a blue-gray as my color. I have selected several values of the same blue-gray, and place them as I see the value in the photo of this foggy scene with stronger darks in the front, fading to lighter values in the background. When washed down with alcohol, you can already get a sense of atmosphere and fog in this picture.

Download bonus materials at artistsnetwork.com/pastel-skies-water

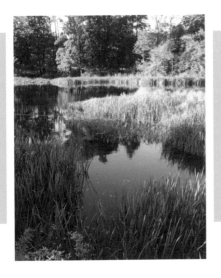 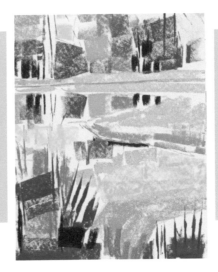 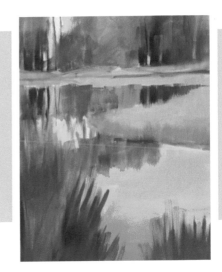

Complementary

This scene is predominantly cool green and blue in a range of values. I've chosen reds as the complement of green, and orange, which is the complement of blue. Where the marsh grasses have turned a light yellow-green, I have selected a light, warm purple—its exact opposite. Make sure to use the right value. For instance, the shaded green marsh grass in the foreground becomes its opposite, a dark value red.

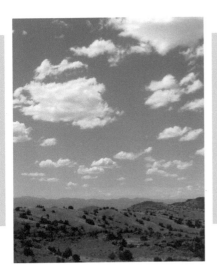 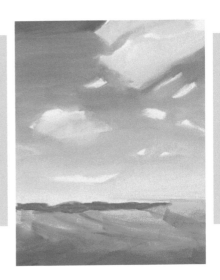

Analogous

I am using a range of purples to underlay the blue sky and turquoise gray under the blue shadowed area on the clouds. For the land area, I chose midvalue orange for under the yellow ochre of the top of the hills. In the shadowed areas, I used dark red for under the brown earth.

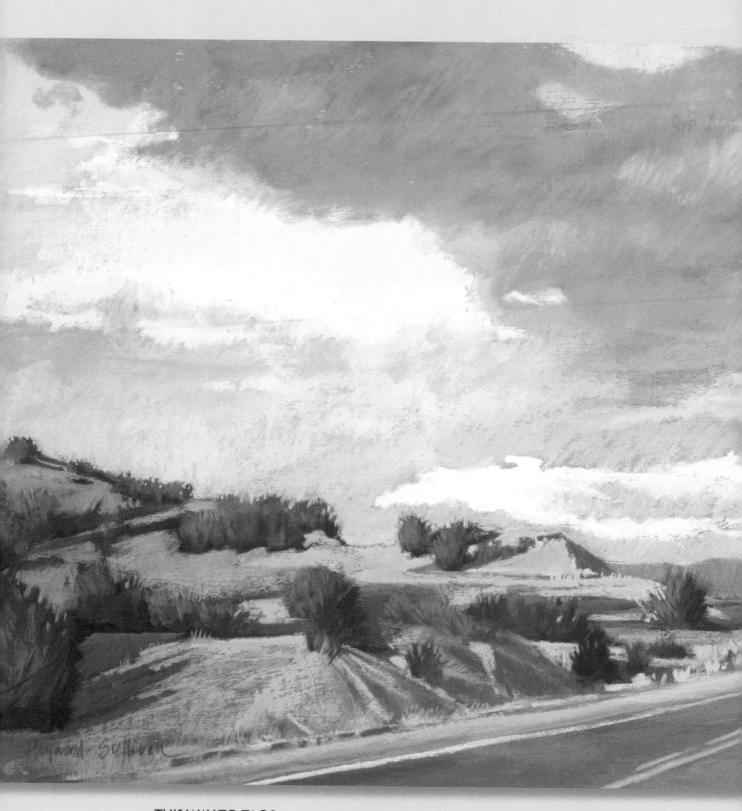

THIS WAY TO TAOS
Pastel on Wallis sanded paper
15" x 30" (38cm x 76cm)

Chapter Two
WHAT IS AERIAL PERSPECTIVE?

AERIAL PERSPECTIVE IN THE SKY

As artists, we are magicians. We take a three-dimensional image, place it on a two-dimensional surface and, through our artistic alchemy, we reconstitute those three dimensions into our vision of the subject. Aerial perspective is part of our artistic toolbox. It is through the understanding of aerial perspective that we are able to transform the two-dimensional surface into a visual three-dimensional work of art.

Linear perspective uses rules of horizon line, eye level, diminishing size and vanishing points to create a correct dimensional portrayal of a three-dimensional volume, often a building. *Aerial perspective* adds the effects of the atmosphere.

Some principles for aerial perspective in the sky:
• As objects recede, they lose detail and get smaller.
• As objects recede, they pick up atmosphere, giving them a lighter, bluish-purpleish cast.
• As objects move into distance, they change shape—cloud volumes become elliptical and flatten.
• As overlapping objects move away, their overlap becomes tighter and thinner.
• Clouds are rounder when viewed from underneath. As they move away, the bottoms flatten as you see them from the side.

VALUE AND THE SKY

In observing a clear sky, you will notice that the color and value are much stronger and darker directly overhead. As your eye moves to the horizon, the sky lightens and often changes color. This is because when looking directly up, you are closer to dark space and as you look towards the horizon, you are looking through more atmosphere, humidity, dust, pollution and particles that are catching and reflecting light. Many artists make the mistake of painting the sky the same value from top to bottom. This value change can often be subtle to see, depending upon weather and lighting conditions. Squinting will help.

Another technique is to simply turn your head upside down to see the range of value from the horizon to up above. By looking at the sky upside down, it is easier to see how great that change can be. It can be quite eye-opening to see the difference.

Try It Upside Down

By turning your head or your photo reference upside down, it is easier to see the value change in a clear or cloudy sky. Note the consistent value change in the sky behind the clouds.

Clear Sky Value Change

There is a value change in the sky from darker directly above to lighter at the horizon.

Cloudy Sky Value Change

Be sure that the sky value changes consistently behind the clouds. Otherwise, the viewer will be confused as to what is sky and what is cloud.

Looking Up

When you look straight up into the sky, clouds will have rounder shapes, with more sky visible around each individual cloud.

In Perspective

The clouds closest to you will have rounder shapes and more sky around them, but as they move farther away, the shapes start to get smaller and flatter with a smaller interval between the clouds. This flattening is from the friction of clouds moving over the air mass trapped underneath. This becomes more visible as you are now viewing them from the side.

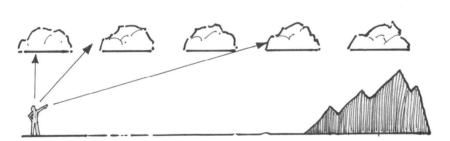

Your Viewpoint in Perspective

This diagram illustrates how perspective affects how you see clouds moving into the distance. The clouds are all set at the same interval from each other. Looking directly up, the cloud above is completely surrounded by sky. As the clouds move away, not only do they become smaller, but you perceive less distance between them. Finally, the diminishing clouds overlap, preventing you from seeing any space at all between them as they merge into a mass.

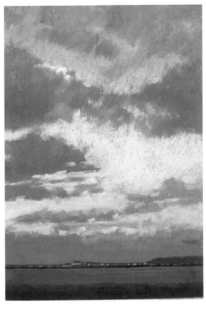

Diminishing Size

Note how the clouds get smaller in size and more elliptical as they move away from you.

AERIAL PERSPECTIVE IN THE SKY

The underpainting we started in Choosing Your Underpainting does not contain all the cloud forms seen in the photo reference. You only create the larger cloud forms because they have more volume and are not as translucent as the smaller cloud forms.

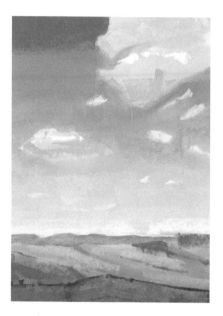

1 CHOOSE THE PALETTE

Place your value extremes—a warm white on the cloud tops and dark olive green in the foreground. Layer in light, middle and dark sky transition zones using ultramarine blue, cobalt blue and turquoise blue. In the clouds, use a range of warm and cool grays. And for the foreground, use earth colors in the midvalue range.

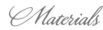 *Materials*

PAPER
UART #500 sanded pastel paper

COLORS

Light value: warm white, cool white, cool gray, warm gray, cobalt blue, ultramarine blue, turquoise blue, pink

Midvalue: cobalt blue, ultramarine blue, turquoise blue, red ochre, orange-brown, yellow ochre, brown, olive green, cool gray

Dark value: warm orange-brown, olive green, darker olive green, red ochre, cobalt blue, ultramarine blue, turquoise blue, brown

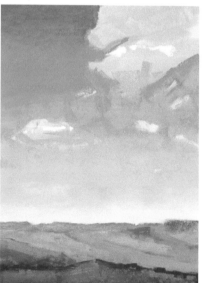

2 DEVELOP THE AERIAL PERSPECTIVE

Begin at the horizon with your lightest colors. Working with the side of your pastel, layer your range of blues, transitioning up from lightest to the darkest blues at the top. As you move upwards, carve your strokes around the smaller cloud forms first, then the larger ones. Leave some of the sky underpainting showing through; do not blend with your finger or try to make it look absolutely smooth. At the horizon, use the lightest sky color to carve the profile of the mountaintop.

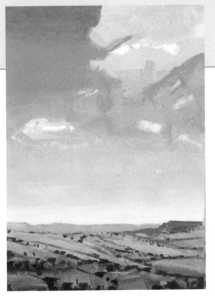

3 FINISH THE FOREGROUND

Use midvalue red ochre, yellow ochre, brown and orange-brown to develop the earth farthest away. Then use the darker red ochre, orange-brown and brown in the closer foreground. Use broader strokes since this area is closer and more detail is visible.

Use the midvalue yellow ochre in the very foreground on top of the darker colors to indicate muted light hitting the area. Starting in the farthest hills with the midvalue olive green, indicate the mesquite, transitioning to larger marks and darker olive green as you come to the bottom of the painting. Now take a very light pink and draw some thin horizontal lines in the sky just above the horizon—these are very distant clouds that are actually picking up warm reflected light from the sunlit earth.

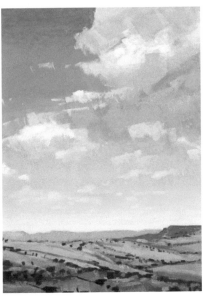

4 PUT IN ALL THE CLOUDS

Use the light warm and cool grays and whites to put in the clouds. The larger forms are already established. Use a light hand and a feathering technique to allow the blue to show through, especially at the edges. The tops will be lighter because they are lit from above by the sun. Then put in the smaller cloud forms right over the blue underpainting, keeping them translucent with some of the blue sky showing through. The shapes will get smaller and flatten as they recede towards the horizon. Add a midvalue ultramarine blue layer of atmosphere over the distant mountains to push them back farther into the distance.

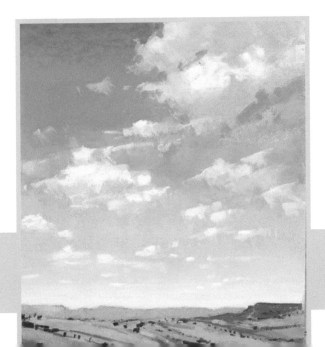

5 A FEW FINISHING TOUCHES

Make a final evaluation. The smaller receding clouds could use a little more pop, so a bit of lighter white will do the job. Using the light warm gray, develop some darker areas across the larger clouds. Using feathered, slightly darker wisps gives the cloud a sense of motion and transparency. Finally, bring some sky holes into the larger clouds by carving a few harder edged shapes into them for visual interest, making sure you use the proper value blue to match the sky behind the cloud!

INTO THE DISTANCE
UART #500 sanded pastel paper
18" x 12" (46cm x 31cm)

AERIAL PERSPECTIVE IN WATER

Use the same principles of aerial perspective in painting water scenes that you used with the sky—diminishing size and detail, distance picking up a bluish cast, overlapping and flattening of shapes. However, applying these principles to bodies of water requires more attention to correct drawing than in skies. Amorphous water vapor cloud shapes are a bit more forgiving if your drawing is off.

Aerial perspective in water is more difficult because of the added factor of reflections, where you not only need to mirror objects accurately, but apply aerial perspective in reverse.

PRINCIPLES OF AERIAL PERSPECTIVE IN WATER

The same principles of increasing distance and diminishing lines in the sky apply to water. The following also apply:

- The value change in the water will reflect the same value change at the same interval, from the sky above.
- Items above the horizon line will reflect at the same interval in water below the horizon line.
- Water reflections are often slightly darker in value than the object or area reflected. This is especially true in calm water, but it is dependent on lighting conditions and the amount of agitation in the water. Rely upon direct observation to determine if this is in effect.
- As a reflection moves closer to the foreground, it loses detail and is more subject to being broken up, dispersed by currents and becoming transparent, revealing objects under the water.

Diminishing Lines

One way to achieve distance in painting water is the use of diminishing lines. Lines indicating waves in the ocean will appear closer together as they recede into the distance. Likewise, in a river or lake, horizontal current lines will get closer together the farther away they are. The reflected sky in water will change in value to mirror the sky above. In shallower water, there will be areas where the water becomes transparent and you can see through to rocks, sand and forms underwater.

The Gravity of Water

It is important to make water forms lay correctly and conform to the contours of the surrounding land. The most important thing to remember is that water lays flat. Whether a distant ocean, or an eddy in a stream, when water isn't stirred up by a current, wave or waterfall, it conforms to the forces of gravity and finds itself laying flat. A sure way to eliminate your painting from a competition is if your water is crooked! If all else fails, bring out a ruler and check if your drawing is correct. Just 1/16" (2mm) can be enough to throw your painting off. To assist you in seeing these small imbalances, use a mirror to reverse your image. Taken out of its normally viewed context, it is easier to see correctable flaws.

GET YOUR DRAWING RIGHT

Getting the basic shapes of your underlying drawing right in the beginning will save you from having to make difficult corrections later. When starting your painting, recognize that the laws of perspective apply equally to amorphic shapes as they do to linear, architectural forms. Some shapes are more difficult to render believably, and practicing these techniques can be helpful in understanding how aerial perspective controls a shape going into distance.

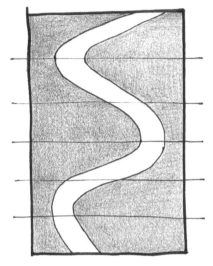

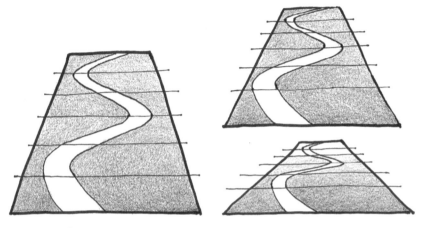

River From Above

Seen from above, a river, stream or creek tends to have relatively even contours. Divide up the drawing by placing evenly spaced, horizontal lines. These will help you see the perspective in the next steps.

River into Perspective

Tilting the picture plane back, the river form recedes. The more the picture plane is flattened, the closer the horizontal interval lines get. Using these lines, map points of the sinuous shape of the river and see how it condenses in the distance. The turns in the river are wider when they turn towards you but then slim down as they travel sideways. If the picture plane goes almost flat, you will only see these turns in the river, appearing almost as separate ponds.

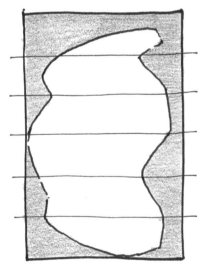

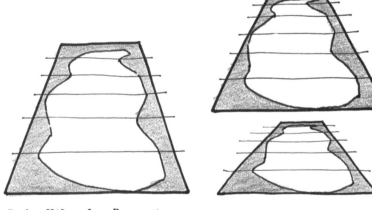

Body of Water Into Perspective

Mapping a form using diminishing horizontal lines can assist you in getting the right perspective of an amorphic shape. The closer shoreline will have more visible volume, but will also be subject to the flattening rules of aerial perspective, which will start to change its basic shape. Farther back, flatten distant shores appear as straight horizontal lines, even if they swoop and have inlets. If you give depth and volume to these distant areas, then you are straightening up the picture plane and you will lose the effect of distance. Always draw what you see, not what you think is there.

Body of Water From Above

Lakes and ponds have irregular shorelines, which can be difficult to draw properly in perspective, especially when shorelines come directly towards you.

WATER IN AERIAL PERSPECTIVE

This painting is of the ocean at midday with light currents stirring up the water. Except for a small band of light blue near the distant shore, the water is darker than the sky because wind on the water is creating waves. But the water still transitions from lighter near the horizon to much darker nearer the viewer.

In the distance, water and current lines are thinner and close together. Near the rocks, the water strokes space out and get wider, and become crosshatched to indicate choppy water.

Materials

PAPER
UART #500 sanded pastel paper

COLORS
Light value: cobalt blue, ultramarine blue, turquoise blue, gray-brown, peach, warm gray-purple, gray-teal, pink-purple, white, warm brown

Midvalue: cobalt blue, ultramarine blue, turquoise blue, gray-teal, orange-brown, warm gray-purple, red ochre, olive green, gray-red-purple, warm brown, warm red-purple

Dark value: very dark olive green, olive green, turquoise blue, cobalt blue, gray-teal, ultramarine blue, brown, warm purple

1 UNDERPAINT VALUE EXTREMES

Complete a monochromatic underpainting using a dark, gray-teal pastel. After it dries, place some light blue in the sky, checking to see if the value is right. The very lightest value, a warm light brown, goes on top of the rock to the right. This value should be slightly lighter than the sky. The darkest dark is a very dark olive green placed in the foreground on the moss clinging to the rocks during the low tide.

2 DEVELOP THE PAINTING PALETTE

Pull out the colors you will use. Try touches of the four different blues at their value areas in the water, lighter at the top and darker towards the bottom of the painting. Put touches of midvalue colors of orange-brown, warm gray-purple and warm brown in the rocks to give them some warmth.

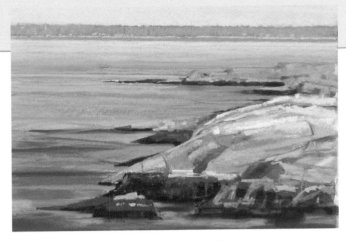

3 BRING UP BACKGROUND

Working from the back forward, start developing correct aerial perspective, with distant objects less detailed and out of focus. Make them lighter, due to atmospheric effects. For the distant tree line, place a glaze of light value gray-teal and warm gray-purple. Use light value peach and pink-purple to draw a very thin line representing the beach and a few small marks representing houses.

In the water, start with a light value blue, almost as light as the sky, to begin your aerial perspective transition down to the first line of rocks. Develop the top line of rocks using the light value warm gray-purple and warm brown. They should be very close in value to the water behind the rocks. At the waterline, place the midvalue olive green and warm brown to represent the moss. Add some darker turquoise blue into the water at the lower left bottom of the painting. In developing the water, work right over where the boat will be placed.

4 THE ROCKS

Render the rocks, making sure to leave some of the underpainting showing, especially in the shadow areas. Use mostly the midvalues of warm gray-purple, gray red-purple and warm brown, and the lighter value gray-brown, peach and warm graypurple. Use the side of your pastel to make chunky strokes. Do not get caught up in drawing cracks and exact forms. Look for the big shapes and get those with simple strokes.

Use dark olive, medium olive and dark brown to render the moss. Again, take some of the dark moss colors at the waterline and drag them down into the water to represent the reflection.

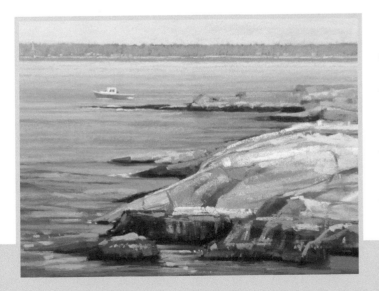

5 FINISH THE WATER, REFLECTIONS AND ADD BOAT

Use the midvalue and darker blues and purples to make wider strokes indicating the currents around the rocks. By varying your marks from long lines to a few short spots, you can give the impression of moving, choppy water. Again, try to leave the darker underpainting showing through and use your blues to draw the lighter blue current lines on top of the water.

Review the rocks and place a few subtle lights going into the background. Add the boat using toned-down colors. It is already a focal point, and you want it to stay put and not come zooming towards you. Use the edge of a broken white pastel to draw the sharp lines and a light value blue to complete the wake trailing behind.

OFF KRESQUE ROCKS, MAINE
Pastel on UART #500 sanded pastel paper
12" x 18" (31cm x 46cm)

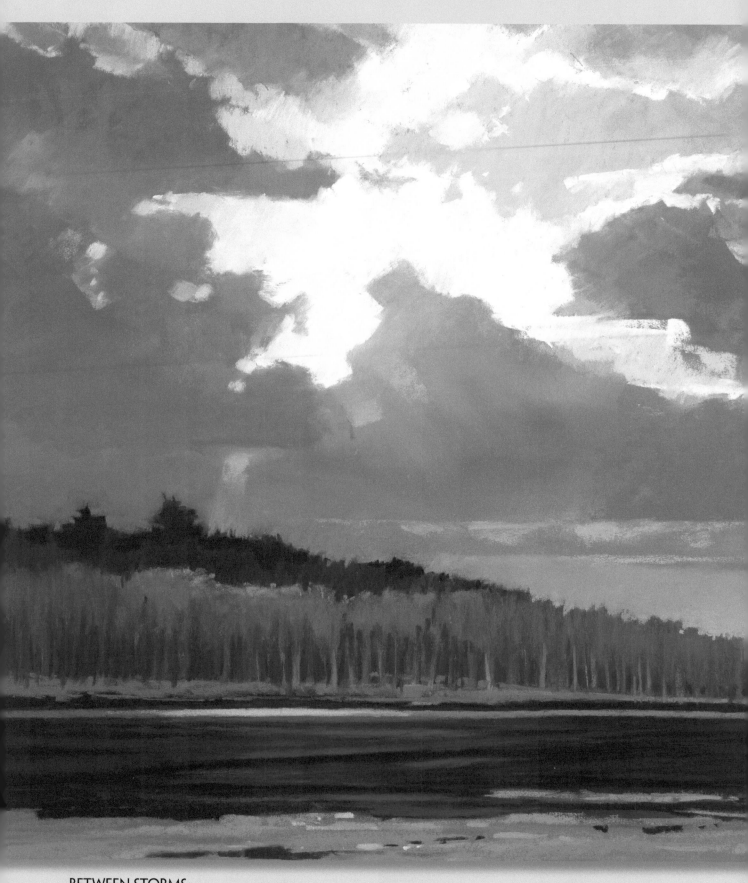

BETWEEN STORMS
Pastel on UART #500 sanded pastel paper
24" x 36" (61cm x 91cm)

Chapter Three
THE LANDSCAPE SKY

The sky is, in my opinion, the most emotional aspect of a landscape. Even a small sliver of sky can set the mood and give a viewer a tremendous amount of information about the weather and time of day. All artists are painters of light and the sky is the ultimate light source. Understanding the "why" of the sky will inevitably impact your painting.

Many of these concepts we learned years ago, before we became artists, in math and science classes where we were too busy doodling to listen carefully. Now, as practicing artists we have context, so let's review some of the science of the sky. Hopefully, these concepts will sit just below the surface of your thought process when you are painting—not so dominant that you are testing yourself to make sure you remember it all and "do it right," but instead to subconsciously guide your hand as it flows over your painting, influencing your decisions just enough to make a difference.

WHY THE SKY IS BLUE

Pure light is white. In the vacuum of space, the sun is white because it contains all colors. Space is black because it has no atmosphere to scatter or break up the pure lightwaves passing through. However, when lightwaves approach earth, they encounter our atmosphere, which is made up of various gases. The dominant blue color of our sky is due to a phenomena called Rayleigh scattering. When light passes through our atmosphere, the longer wavelength light of reds, oranges and yellows passes straight through undisturbed, and the shorter wavelength light of indigos and violets get absorbed by the gases. However, the blue wavelength light bounces off the particles of atmosphere and gets scattered. This is what we see, this scattered blue light. And as the atmosphere becomes denser closer to the ground, the blue light gets more scattered and the more it scatters, the lighter blue it gets. Now, for a really cool fact: Around 2.8 billion years ago, before plants and animals, our sky was not blue. Then, a bacteria—*cyanobacteria*—evolved whose byproduct was oxygen, which gave lightwaves a substance to bounce off.

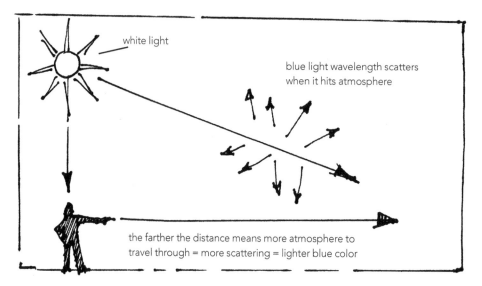

Rayleigh scattering

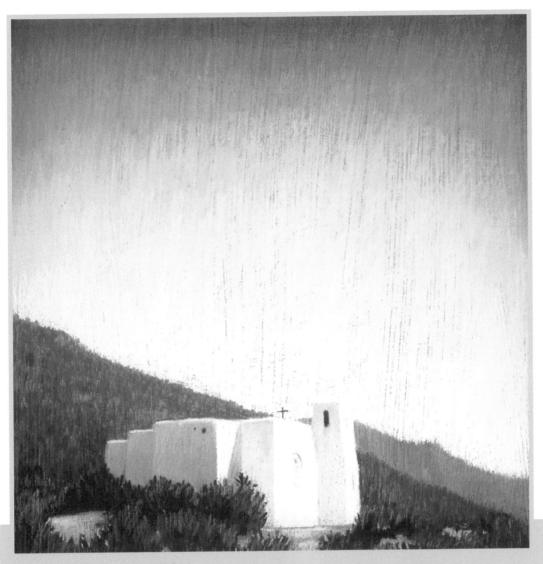

TURQUOISE TRAIL MISSION
Pastel on handmade surface
10" x 10" (25cm x 25cm)

A Matter of Altitude

Altitude has a great effect upon the value of a blue sky. Higher up, the scattered blue light hasn't had as much atmosphere to travel through, and there are fewer particles of dust and pollution. So at higher altitudes, the sky will appear bluer at the horizon than at sea level, and it will transition to a darker blue above as well.

CLEAR SKIES

For a landscape artist, there is nothing better than a blue sky day. When the skies are clear, we have abundant and steady light, with no inclement weather or moving clouds creating pesky, ever-changing shadows.

THE SKY IS NOT ALWAYS BLUE

This is a good time to discuss assumptions when painting. We assume that a clear sky day will have a blue sky, just as we assume trees are green and water is also blue. Close observation will reveal that all these assumptions are flawed and that other colors can not only be observed, but can also be dominant.

There are many factors influencing the color of a clear sky. You have the value change discussed in the aerial perspective chapter but the value also depends upon which direction you are facing in relationship to the sun. If the sun is in front of you, the sky will appear lighter (glare), and if the sun is at your back, the sky will be a darker intense blue.

Clear skies also exhibit other colors depending upon particulates in the lower atmosphere. Artists often exaggerate sky color to lend their paintings a specific mood. The paintings here display skies that are affected by moisture in the atmosphere and time of day. Regardless of the color of the sky, remember the value change from top to bottom or else the sky will lose its dimensionality and look flat.

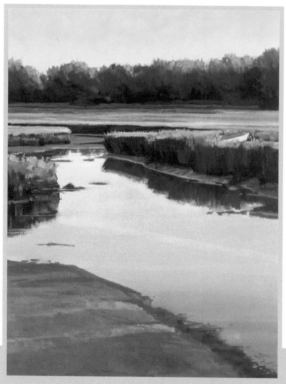

SPRING TIDE
Pastel on Pastelmat
27" x 20" (69cm x 51cm)

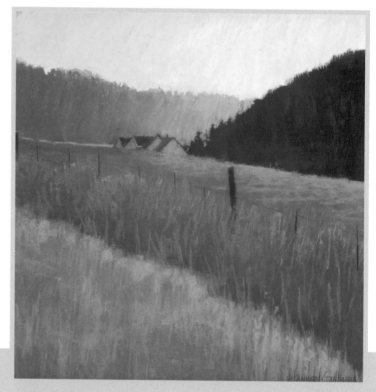

FIRST FROST
Pastel on UART #500 sanded pastel paper
16" x 16" (41cm x 41cm)

INFLUENCES ON SKY COLOR

All of these images are similar, midday clear skies.

Clear Blue Sky

This is the quintessential clear sky day with a beautiful value transition from the top of picture to the tree line. You can clearly see the blue-tinged color of the atmosphere as it drops down over the hills behind the trees in the midground. The sky gets warmer as it lightens towards the horizon, with touches of warm yellow.

Urban Smog and Pollution

Just north of the Mediterranean, the city of Granada sits in the shadow of the Sierra Nevada Mountains. Pollutants rise up into the lower atmosphere, reducing distance visibility. Midday sun and smog create glare and leave a white-yellow grayish cast. This hovers close to the ground, where the atmosphere is more dense. Mountains can also reduce the movement of air that would clear smog. Especially in hot summer months, inversions can occur where the air stagnates and becomes increasingly polluted. A blue sky is impossible to see, even when looking straight up.

Smoke and Dust

Fires in Arizona floated hundreds of miles into the Sangria de Cristo Mountains near Albuquerque, New Mexico. Ash and particulate matter from smoke obliterated a midday blue, leaving a sky that looks pure white with virtually no value transition. Unlike the yellowish gray cast of smog, smoke creates a telltale blue haze over distant objects.

Fog

In this picture, a thunderstorm has just passed, which quickly cooled the air. Low-lying fog is created when there is a difference in temperature between the ground and air. The rocks and plant matter still hold onto earlier warmth. Fog is fluid, a cloud down by the ground. In depicting fog, create a look of transparency with differing opacities to give the impression of movement. Since fog lies low, you will often see blue sky above.

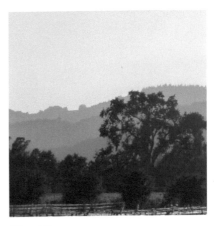

Humidity

Humidity is also moisture in the air, but it occurs higher in the sky, like smoke. Higher humidity occurs in warmer climates and is moved around by prevailing winds. A humid sky will have a very subtle value transition from top to bottom. Humidity will also change the color of the sky; in midday, it generally warms colors a bit.

PAINTING THE CLEAR SKY

This step-by-step demonstration will show you the layering and colors to paint a vibrant, clear blue sky. Use analogous colors for the background underpainting and complementary colors for underpainting the trees and foreground. You will discover that this painting contains much more than blue pastel!

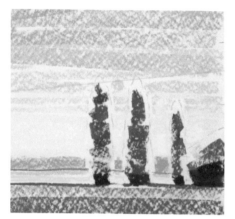

1 APPLY UNDERPAINTING COLORS AND VALUES

Lay in basic shapes, then decide which colors you wish to use in your underpainting, then choose the right value. Try to match the final value you want as close as possible.

Establish the value transition in the sky by putting the midtone warm purple at the top and lightening down to a light warm purple at the horizon. The trees and foreground field contain dark warm red, dark brick red and dark warm purple. Do not apply the dark red of the trees out to the extreme edge of their outline. The back field and tree line are mid- and light-value warm yellows and yellow ochres.

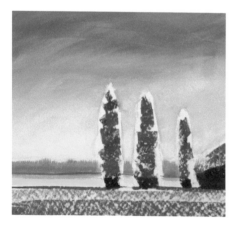

2 WASH DOWN THE BACKGROUND

Use water and a 1" (25mm) flat brush, wash in the sky underpainting. Try to maintain the transition in value evenly behind the trees. In the background tree line, use upward strokes so the ragged end of the brush creates a broken line, which already looks like the tips of distant trees.

Materials

PAPER
UART #500 sanded pastel paper

BRUSHES
1" (25mm) and ³/₄" (19mm) flat wash synthetic brushes

LAYOUT COLOR
Midvalue blue-gray hard pastel

PASTELS
Light value: warm purple, peach, yellow, orange-yellow, yellow ochre, warm and cool blues (cobalts, ultramarines and turquoises)

Midvalue: warm yellow, yellow ochre, warm gray-green, warm brown, red-brown, orange-brown, teal, warm and cool blues (cobalts, ultramarines and turquoises), warm purple

Dark value: warm red, brick red, warm purple, green, warm green, olive green, cool green, warm and cool blues (cobalts, ultramarines and turquoises)

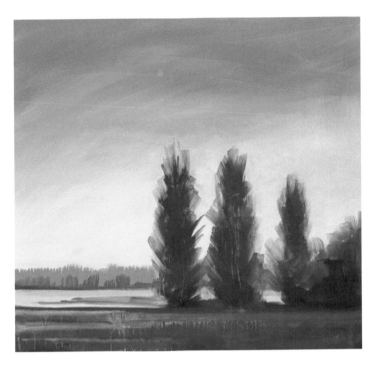

3 WASH DOWN THE FOREGROUND

Use an old brush with ragged edges to create what look like branches when washing down the underpainting. Because the water stays wet longer than alcohol, it has time to create interesting drips, which might make it through to the final painting. Trees thin out at the end of their branches and more light comes through. Indicate this with sky holes, but also by lightening the value of the tree mass at the edges.

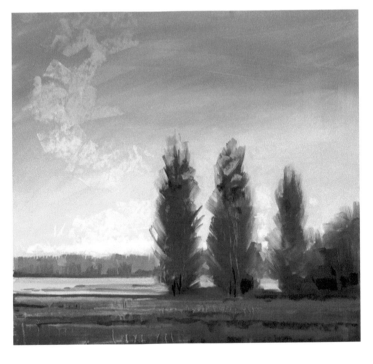

4 ESTABLISH VALUE EXTREMES

Fill in the lightest light—a warm light blue near the horizon— and the darkest dark—a very dark warm purple for the tree trunks and underbrush base on the right side. Do not go lighter or darker; all other values should fall in between these two extremes. Now go through your palette of colors and pull out the majority of specific pastels you will use for the final painting. Test them in their location on the painting, trying to match values. You can easily see if you have the right value when the color doesn't create an edge when you squint your eyes.

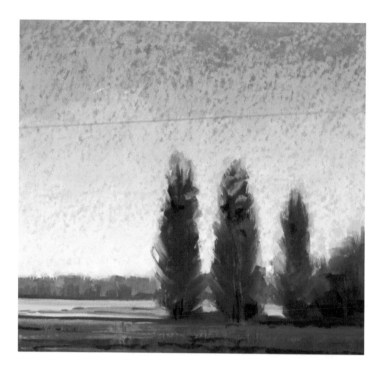

5 FIRST PASS OVER THE SKY

Since the sky is dominant in this painting, work carefully to establish the correct colors and value relationships. Apply the pastel by using the side in large, broad strokes, which is a good way to cover a large expanse evenly. To get the rich, vibrant color in this particular sky, use a range of warm and cool blues: cobalt, ultramarine and turquoise in a light to midvalue.

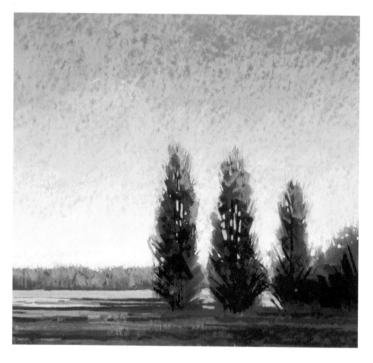

6 WORK OVER ENTIRE PAINTING

Place pastel over the whole underpainting. Layer several shades of dark green over the foreground field. Use a midvalue turquoise on the lower left side to indicate a slight blue-cast light reflected from the sky.

The distant tree line gets some detail work in light to midvalue warm gray-greens, with midvalue warm brown at the base to indicate deeper shadows. The upright trees have a dark olive green applied, transitioning to a darker, cooler green at their base.

Create some sky holes as you begin molding the shape of the trees. Bring the background sky color into the underpainting to sculpt the branches. Apply a midtone warm orange-brown under the tops of the trees before dropping some light orange-yellow ochre to indicate the tips catching the last rays of "magic hour" sunshine.

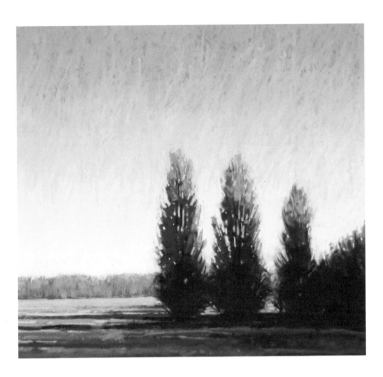

7 TIGHTEN UP THE SKY

Use some harder pastels in the same blue colors and values to try and break up that cottony look of the sky. Don't totally eliminate the purple underpainting, but just quiet it down a bit. Reduce the texture of the purple underpainting towards the horizon, allowing the texture to be more pronounced in the overhead sky closer to the viewer. The last thing to do in the sky is drag a very light peach by the horizon to warm it up a bit. This warmth helps connect the sky to the earth as it represents a reflection of some of the light striking the earth.

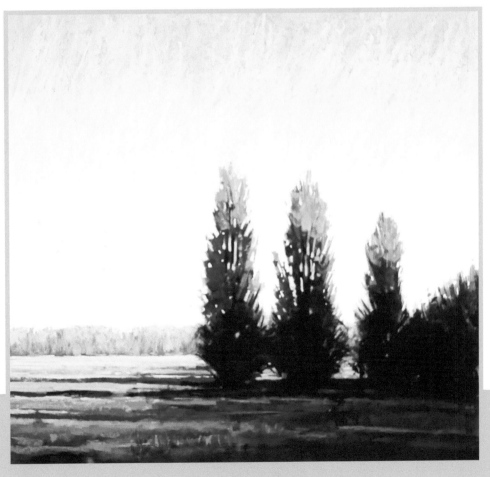

8 FINISHING TOUCHES

Time for a little more work in the foreground. Apply midvalue teal from the left side to just under the upright trees for more reflected light from the sky. A bit of the same midvalue red-brown across the lower left ties the field and trees together.

Use a mirror while you do a painting. It helps to check proportions, determine whether lines are straight, show how value relationships are developing and ultimately will help you decide when you're done.

SONOMA THREE
Pastel on UART #500 sanded pastel paper
20" x 20" (51cm x 51cm)

ABOUT CLOUDS

Clouds are beautiful, complex, perplexing, difficult to paint, frustrating, inspiring, humbling and integral to the art of landscape painting. Quite a description for nothing more than clumps of water vapor. Handled well, they can do many things for your painting. They can tell the viewer the time of day and the time of year. They set the mood of a painting with their depiction of the weather—be it benign fair weather clouds, a threatening thunderhead, dull gray rain-laden clouds or moody fog. They can be the focus of a painting or just a supporting player. But at some point, every artist will need to understand how to paint them. This section will provide a bit of insight into the nature of clouds.

OBSERVE, OBSERVE, OBSERVE

Spend some time observing the sky. Grab your sketchbook and do some quick sketches of clouds to just wrap your head around how they move, evolve and feel under your pencil. Note their range of values; how dark, how light? What are their relative sizes and their relationship to the sky and each other?

THE LIGHT WITHIN CLOUDS

Light conditions for clouds are not just restricted to direct sunlight and shadow. The more subtle reflective and translucent light is what makes clouds magical. You will find both visible in *Momentary Majesty*. This requires close observation, because it can be quite easy to lose your way when rendering a cloud. Try sketching it first and use some of the techniques on the following pages, especially breaking down the cloud into simplest forms, and the give-and-take technique to separate the different cloud forms.

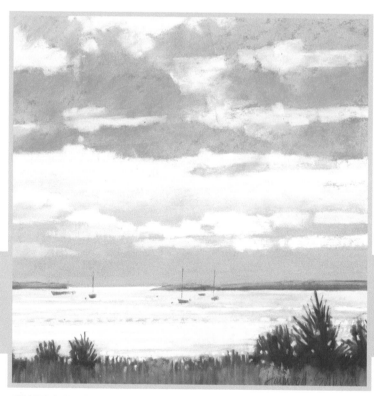

GLISTENING
Pastel on UART #500 sanded pastel paper
12" x 12" (31cm x 31cm)

What delights me about this painting switch from dark clouds on light sky to light clouds on dark. It sounds improbable, but we all recognize this type of sky. I could never have come up with this image on my own, but direct observation revealed this interesting and fascinating value swap!

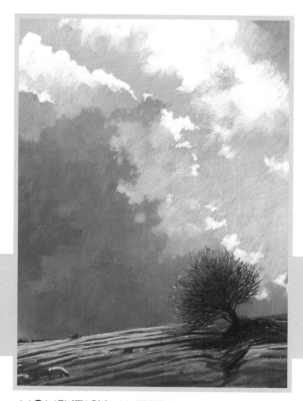

MOMENTARY MAJESTY
Pastel on Wallis sanded pastel paper
30" x 25" (76cm x 64cm)

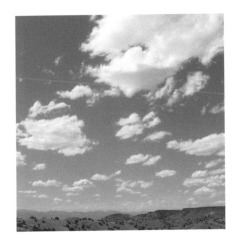

Cumulus

These are the beautiful cottonball-topped, fair weather clouds you see on a clear, sunny day. They generally dissipate at day's end and are not rain clouds. They have distinct, rounded shapes against the blue sky. Keep values light, midvalue at the most underneath. No dark menacing tones or colors on these benign beauties! They are not as common in wintertime.

Cumulus Fractus

You will see these wisps of water vapor at the edges of cumulus clouds as they form and evaporate. They have no real volume and should be rendered as if almost transparent, with lots of sky coming through and no real volume to their shape. To paint them, render the sky underneath completely first and then scumble these wisps lightly on top.

Stratocumulus

This is the most common cloud, low-lying with a dark base and made up of light and dark clouds. You'll see these at all times of the day and in any season. They often bring precipitation.

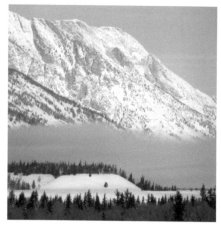

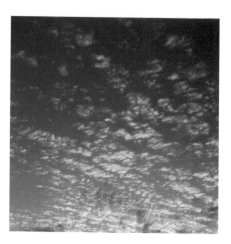

Stratus

The lowest lying cloud often appears as fog or mist.

Altocumulus

A mid-level cloud, made up of a layer or clumps of cloudlets, sometimes called a mackerel sky. When the sun is above, altocumulus can have a darker underside.

Cirrus

High altitude clouds, cirrus are made of falling ice crystals and can be caused by contrails of water vapor coming off high flying jets. They are also called mares tails for their ethereal swishy appearance. They are linear and thin, without much volume, so when painting, use light value marks, no dark underside and paint them over an already painted sky.

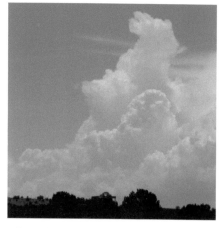

Cumulonimbus

This is the big thunderstorm cloud that evolves from the benign cumulus cloud. It has an anvil-shaped top and is the cloud that produces thunder and lightning, hail and rain. It has the cottonball appearance of the cumulus but the undersides become dark and menacing, especially when you are underneath it.

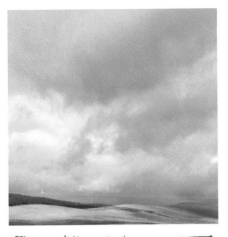
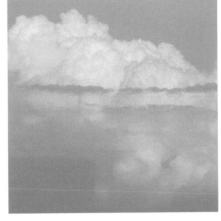
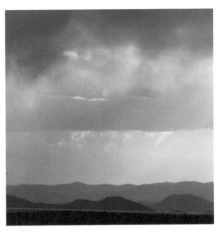

Pannus (Stratus Fractus)

These are the small dark rain clouds you see scudding underneath stratus clouds. They are always dark and wispy, and indicate rain is imminent. Paint them last, on top of existing clouds.

Velum

One of my favorite clouds to paint. They accompany cumulus and cumulonimbus clouds and are the thin horizontal streaks of cloud that float in front of and around the bigger clouds. They can be dark or white.

Virga

Virga is rain that doesn't reach the ground. It can be seen underneath rain clouds as a blurred area, often with a distinctive angled direction from the cloud towards the ground. It is most easily seen, and most dramatic, around sunset.

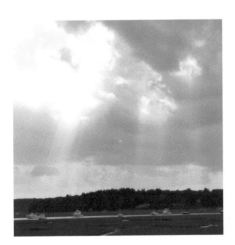
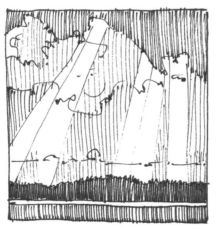

Crepuscular Rays

Now you know the name for those streaks of light coming through mid- and low-level clouds. Paint sparingly and with a light hand. They look dramatic but a little goes a long way.

BREAK IT DOWN

Clouds are not hard shapes. Their volumes are made up of water vapor that is constantly changing and evolving. To accurately depict a cloud, you need to see where cloud edges transition from well-defined to soft, amorphous and translucent. Subtle changes in value, layering and edge are more accurate and effective. Establishing a good composition and focal point will allow you to develop your cloud forms to support your painting, with sharper edges leading your eye and softer edges becoming support and out-of-focus areas.

The next few demonstrations use the same handful of pastels. Try to do them using your pastel on its side. Work with a light hand and without any finger blending.

Cloud shapes are inherently difficult to paint. One way to make them easier is to start with the outline, then break that down into middle-sized shapes and then break those up into even smaller shapes.

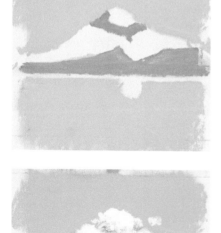

1 Start with the cloud outline against your blue sky.

2 Pick up a midvalue gray to represent the shadowed area and break the cloud up into no more than five solid shapes.

3 Working with a light value gray and white, start breaking down this handful of shapes into smaller shapes, softening the hard edges and being careful to blend your mid- to light value transitions.

Materials

PASTELS:

Light value: blue gray, purple-gray, warm and cool gray, white, warm and cool blues (cobalts, ultramarines and turquoises), warm purple

Midvalue: purple gray, warm and cool gray, warm and cool blues (cobalts, ultramarines and turquoises), warm purple, blue gray, teal blue, muted orange

Dark value: purple-gray, warm gray, cool gray, warm and cool blues (cobalts, ultramarines and turquoises), warm purple

LOST AND FOUND EDGES

Lost and found edges are where value relationships are so close that you can barely see the difference between them. All clouds have these softer edges where cloud volumes meet the sky or each other in their interior. They are likely located on the underside of a cloud and in shadowy areas.

1 ESTABLISH BASIC SHAPES

Place basic shapes and values down on your paper. Use a midvalue purple-gray for the cloud and layer a midvalue warm blue over a midvalue cool blue for the sky.

2 DEVELOP COLOR UP TO EDGES

Work color up to the edges of the shapes so they touch. Add some lighter value purple-gray for the lighter cloud areas. Add some darker gray to the underside of the cloud and also make a new dark gray cloud underneath to the right. Start softening edges where cloud meets cloud and cloud meets sky by working on the side of your pastels.

3 WORK ON EDGES WHERE SIMILAR VALUES MEET

Meld the edges together, working value on value. The difference in value between the underside of the cloud and new dark cloud should be barely discernable. This is often where you find lost and found edges—in the shadows of clouds.

GIVE AND TAKE

To produce believable clouds, work on the cloud area first (positive space) and then modify by carving in the sky (negative space). Go back and forth, giving and taking, until the shapes are pleasing to your eye. One way to approach this is to place your pastel in both sky and cloud areas and work the edges of both up at the same time. You don't finish either the sky or the clouds first because they need to develop together.

1 PLACE DARKER VALUE AREAS

Choose your simple shapes and select a midvalue blue for the sky and midvalue gray for the darker cloud values, laying down your first layer of pastel in the dark areas only.

2 CHOOSE LIGHTER VALUES

Place a lighter value gray in the light cloud. Use a slightly lighter blue for the sky and use it down by the cloud, establishing a slight value transition from bottom to top. At this point, the whole painting has pastel on it.

3 CARVE NEGATIVE SHAPES

Bring some of the sky into the cloud by carving some negative space blue shapes. Now bring some of the light cloud negative shapes into the darker cloud.

Then, do the reverse by bringing the darker cloud back on top of the lighter cloud. Go back and forth, carving your shapes until you are satisfied. A final look is needed to be sure you haven't created monster faces in the clouds!

HARD EDGES

A hard-edged cloud is a bit of an oxymoron, considering that a cloud is just gas. However, with fair weather cumulus beauties, you do get these wonderful sharp shapes against clear skies. Use these sharp edges sparingly. Use them to bring attention to a focal point or to lead your eye. Do not use them all over your painting. They will appear at the top of a cloud, where the cloud is evolving upwards into the sky.

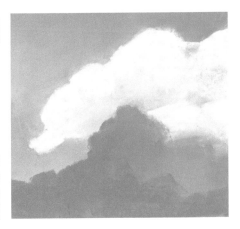

1 LAY IN SHAPES AND VALUE
Here, you have both light cloud against dark sky and dark cloud against light cloud. Put in the darker value shape of the sky and the darker cloud to establish the rounded shape of the top of the clouds.

2 BUILD UP THE COLOR
Add in the lighter value gray for the lighter areas of the cloud. Put additional blues in the sky, indicating a bit of transition from lighter to darker. Put some darker, light-value gray to give the light cloud some volume, working the color into the rounded shapes.

3 WORK ON THE NUANCES
Imagine the direction of the sun. If the cloud tops are rounded volumes, then they will be lighter towards the sun and get darker away from it. Work up the round volumes to indicate these lighter and darker areas. They will be very subtle.

APPLYING CLOUDS TO THE SKY

What do you paint first? Do you paint the sky over the entire painting so you can get the value transition just right and then place the clouds on top? Or do you draw outlines of the clouds and put the sky in around the cloud shapes? Turns out it is a little bit of both.

When painting the sky, remember the value transition, but don't forget that clouds are water vapor and not solid opaque forms. You don't want to create strongly defined cloud shapes and paint sky around them. Be sensitive to the transition zone at cloud edges where the sky tucks in behind. There are areas of transparency and translucency, and they can be a lot of fun to paint!

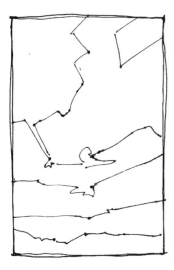

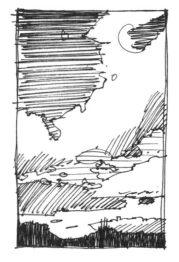

1 FEEL YOUR PAINTING

The first step is to do a simple, one-minute basic shape sketch to get a sense of the composition. Does it fit the proportions of the vertical cropping? Do you get the sense of drama you are looking for?

2 CREATE VALUE SKETCH

Get a better sense of the feel of the image. Don't dawdle over details, but search for the flow of the basic shapes. Feel the vertical thrust of the cloud and notice where the values swap at the bottom of the painting; at the top, the clouds are light on a dark sky, and at the horizon, are dark clouds are on a light sky. You know you've found your subject when your quick little thumbnail sketch excites you and you can't wait to start painting!

3 TRANSFER DRAWING TO PAPER

Your scaled-up drawing should closely resemble your final thumbnail. Create simple basic shapes. No value and no sketchy linework. If you need to make corrections, there is no need to erase these errant lines. They will disappear during the underpainting. Remember to use crop marks on both your reference image and on your paper to aid in doing a properly proportionate scale up. You know you've found your subject when your quick little thumbnail sketch excites you and you can't wait to start painting!

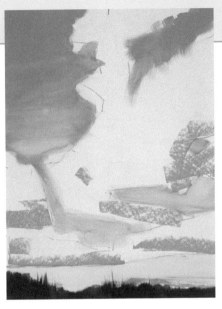

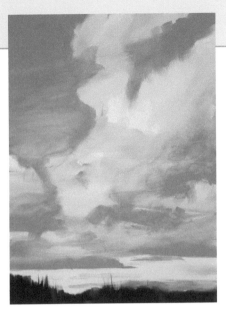

4 CHOOSE UNDERPAINTING COLORS

Create a monochromatic underpainting using purple to add a warmer analogous counterpoint to all the blue. Select two purples, a midvalue warm purple and a very dark warm purple.

Choose underpainting colors as close as possible to the same value as the final painting. When applying the pastel, do not oversaturate the paper with pastel. Use broad strokes on the side to apply the pastel, following your basic shapes. Place the darkest value only at the cloud bottoms. Don't place pastel all the way up the tree line.

Do not put any color in the lightest areas. When you wash this down, you will be able to move the pastel around like watercolor, creating lighter washes.

5 WASH DOWN SKY BEHIND CLOUDS

Using the 1" (25mm) flat wash brush, wash down the sky areas only, starting at the top and controlling errant alcohol drips. Leave the clouds untouched. Get the transition value. Also wash down the landscape at the bottom so you can see your darkest value. Use your brush to give the tree line a feathered look. Let it dry fully before moving on to the next step.

6 WASH DOWN THE CLOUDS

Work on the cloud undersides farthest away, washing down the loose pastel. Move some of it into the lighter cloud areas. There should be enough residual pastel on your brush to tint those lighter clouds. Once this dries, it almost looks like a black and white version of the painting—a true monochromatic image. After drying, take some time to evaluate the composition. Any changes at this point are easy to make.

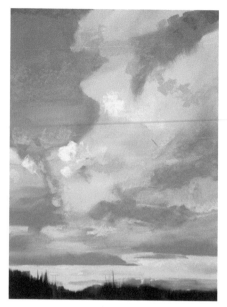 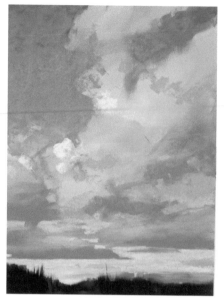 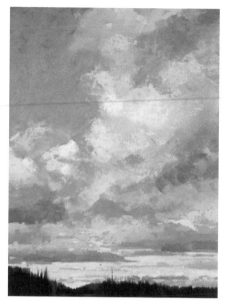

7 ESTABLISH VALUES AND HUES

Establish your value range by using a very dark warm purple for your darkest dark and place it in the tree line. Midway up is the lightest light in the cloud form, so place a slightly warm white there.

For the sky, choose warm purples, turquoise blue, cobalt and ultamarine blues in three value ranges—light, middle and middle-dark. Mix these three blues in every area of the value transition, from top to bottom, using the purple to tone the blue down a bit. Using several blues allows you to adjust the warm/cool temperature of the sky. One will dominate but using the mixture of three blues over the purple underpainting makes the sky vibrate with interesting color.

8 DEVELOP THE SKY BEHIND

Focus on developing the sky first just as you did with the underpainting. Work on the side of your pastel with the larger shapes, and for now, stay away from developing the edges where cloud meets sky. Focus on getting the value and color of the transition established. Pick out the smaller cloud holes and include them in the development of the color transition. When the blue starts to get too blue, scumble on a bit of the warm purple to neutralize the blue.

9 WORK UP THE CLOUDS

Still working on the side of your pastel, work on developing the clouds. Use the warm and cool grays, warm purple and blue-gray in the light value for the upperside of the clouds and in midvalues for the shadowed undersides. Break down the cloud forms into smaller shapes and use the technique of give and take to render them.

No area is finished yet and don't start to address the transition zone where cloud and sky meet.

When Blue is Too Blue

One of the reasons to put purple behind the sky is because sometimes blue is just too blue. The human eye can see innumerable colors and subtleties in the sky, but photos do not have nearly as great a range. If a strong blue sky dominates your reference image, then any color subtleties are lost.

Applied with a light hand, orange will neutralize the strong blue as complements mixed together create gray. Layering in analogous colors, such as using a purple underpainting and lightly layering in the complement are both techniques that can be used to make a blue look just right.

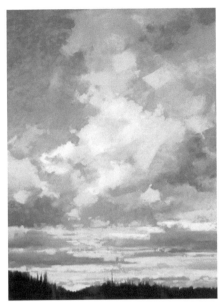

DEVELOP THE EDGES

10 At this point, you are close to leaving your photo reference behind. Moving to finish marks, downplay the light at the top of the sky. You don't want the focus to travel up. Try to leave some of the purple underpainting showing through to mitigate too much gray. Use a mirror and squint to review your basic shapes and see any outstanding flaws. Develop some of the edges where dark and light meet. The only hard edge will be towards the center of the painting, where the cloud is the lightest against the sky. Leave most of the cloud edges feathered and soft, using the lost and found technique.

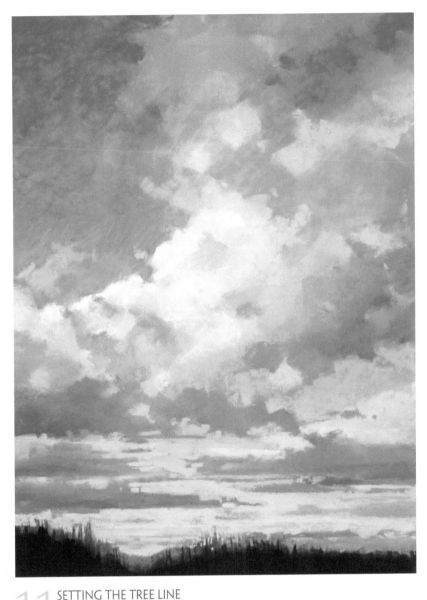

SETTING THE TREE LINE

11 Now you can finish work on the dark bottom tree line. Layer some midvalue teal blue in the zone between sky and trees to act as a buffer and indicate the trees going into the distance. Moving up into the lightest cloud area, play with making some bulbous cumulonimbus shapes to indicate cloud type, but do it sparingly. All you need is a suggestion of cloud form and your imagination will do the rest. Add a bit of midvalue muted orange warmth to the cloud bottoms. The warmth of the earth is reflecting a small bit of light upwards, connecting sky and earth.

Finally, using a harder white pastel on its side as a blending tool, do a final bit of blending in the light value areas. Use a light blue pastel on its point to define the smaller shapes of the receding clouds across the bottom and give the painting a final distance.

THE CHANGEABLE SKY

One of the few things in life you can count on is that the sky is always in a state of flux. I hope we can never accurately predict the weather. If science ever gets us to that point, we will have lost some of the wonder and magic of our world. Of course, there are some very predictable changes that we can make use of in our paintings. The change of the seasons gives us environmental and lighting conditions, and time of day dictates universal themes of sunrise, sunset and high noon flat light. The effect on our paintings can be as subtle as a slight change in the angle of a shadow or as dramatic as a brilliant sunset, and being aware of them not only gives us greater understanding of what we are painting, but expands our toolbox of techniques.

PAINTING SEASONAL SKIES

Seasonal skies offer a changeable feast of lighting conditions. Next time you do a painting, try and offer some clues as to the time of year. In *Peaceful Morn*, you can tell that it is close to the end of summer. The grasses have turned slightly towards a warmer hue, and the entire painting has taken on this warm cast. It is a sunny day, but there is a lot of humidity in the air, leaving no blue in the sky due to the scattering of light off the heavy air. The languid light, the boat at rest, the flat water, even the title all reflect the attitude and mood of the painting.

TIME OF YEAR OBSERVATIONS

This series of paintings is of an iconic western barn just outside of Bozeman, Montana. It sits in front of the Bridger Mountain range at an altitude of 4,820' (1,469m). Because of the altitude and relative lack of humidity, clear skies are brilliant blue down to the horizon—more so than at lower altitudes where the atmosphere is denser and causes the sky to get much lighter at the horizon.

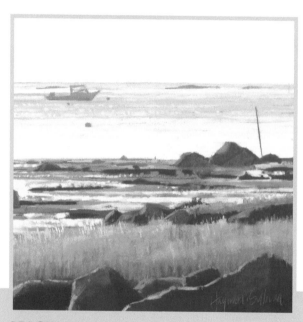

PEACEFUL MORN
Pastel on UART #500 sanded pastel paper
12" x 12" (31cm x 31cm)

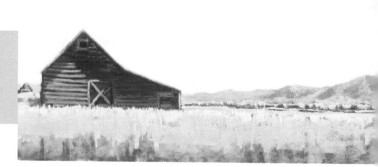

Summer, Montana 2:00 P.M.

Cumulus clouds have evolved into cumulonimbus clouds where thermals of warm air are being pushed upwards off of the mountain range. Streaks of velum clouds accompany the building thunderheads. The light is as close to overhead as it will get. Because Montana is located far north of the equator, the sun will never be directly overhead. There will always be light on this side of the barn, but the shadows from the eaves will be deeper than any other time of year.

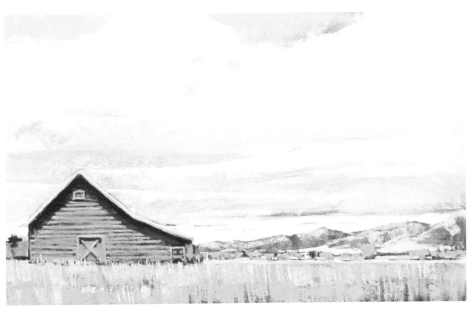

Autumn, Montana 2:00 P.M.

At the spring and autumn equinoxes, the skies are alive with some of the best cloud formations of the year, especially in the late autumn, when coupled with a longer sunrise and sunset period. Low-lying stratocumulous clouds pick up a warm glow of reflected light off the earth, especially if there are sky holes allowing streaks of sunshine to bounce off of the golden prairie grasses. Adding this warm toning to the undersides of the clouds will help to unify your painting, reducing the cut-in-half appearance of cool sky above and warm earth below. At 2:00 P.M. the barn has some shadows from the eaves but they are much smaller as the sun starts to change location and the day starts to shorten.

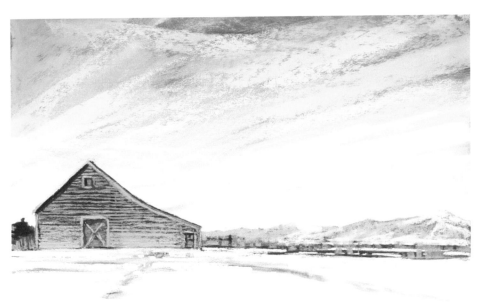

Winter, Montana 2:00 P.M.

In the winter, the angle of the sun is lowest in the sky, creating longer shadows throughout the day. Because of the lower sun, the "magic hour" lasts longer, as it skims along the horizon, than in the summer when the sun just dives down. This makes it a good time of year to paint the golden light of sunsets and sunrises.

The dry, cold air of winter isn't as conducive to the puffy, warm-weather cumulus and cumulonimbus clouds. Snow comes in on dark gray nimbostratus clouds and on bright clear days, visible clouds tend to be the high altitude cirrus with their streaks of water crystals. The sun now hits the barn almost straight on, with few visible shadows. The whole painting takes on a cooler cast without the warmth of the grassland to reflect up onto the barn, and the high altitude clouds are too far away now to be affected by reflected light.

CHANGING LIGHT
THROUGH THE DAY

Artistically speaking, it helps to be an early riser rather than a night owl, unless you prefer painting night scenes. Some of the best lighting conditions happen in the early morning and just after sunrise. The angle of the sun creates shadow shapes and atmospheric conditions, like morning fog, that can give interest to subjects that are boring and uninspiring during midday. Likewise, in late afternoon there is a time period known as the "magic hour," where the angle of the sun again rakes in steeply and everything glows for a brief amount of time before it dips below the horizon. The effect is hard to catch on paper unless you are set up and ready to go, but it is a wonderful exercise in painting with abandon to try and capture the fleeting light of the setting sun!

TIME OF DAY OBSERVATIONS
Along the coast, the sky is not the same clear, strong blue because humidity and salt condense in the lowest layers of the atmosphere. As a result, the sky near the horizon gets quite light, often with yellow, peach or pink mixed in. On a mid-summer day, it is interesting to observe the development of clouds as shown in these four paintings done from the same viewpoint overlooking a marsh leading out to Massachusetts Bay and Cape Cod beyond.

DRAMATIC LIGHT
You can harness time of day lighting to create a heightened sense of drama in your paintings. The early morning mountain light of *Grazing Three* casts long, dark shadows across a plain that, if painted during midday with lighting from above, would look flat and uninteresting. The midday light filtered through leaves creates beautiful patterns of light on the adobe wall of *High Noon Corrales*. The sliver of blue sky with a building cumulonimbus cloud indicates how strong the light is and why the shadows on the building are so sharp. *Day's Last Glory* is all about the dramatic light of the magic hour at the end of the day. The foreground has gone dark while the horizon is still catching a bit of warm sun. Because the foreground is dark, it becomes the perfect setting for the reflection of the brilliantly lit and colored cumulonimbus cloud above. If the foreground were still sunlit, the reflection would not be as visible and have as much dramatic capacity.

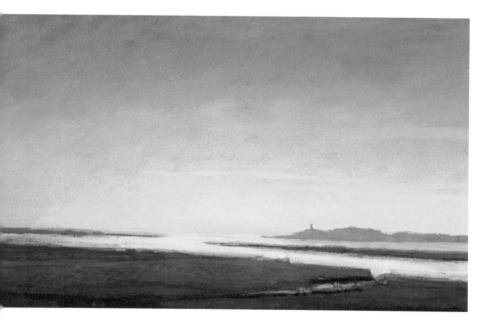

Summer Along Coastal Massachusetts Just Before Daybreak

In the summer, many days along the coast begin clear and cloudless. As the sun starts to rise, the sky will often turn varying degrees of warm colors, with the only clouds visible being a few horizontal wisps of high altitude cirrus.

Download bonus materials at artistsnetwork.com/pastel-skies-water

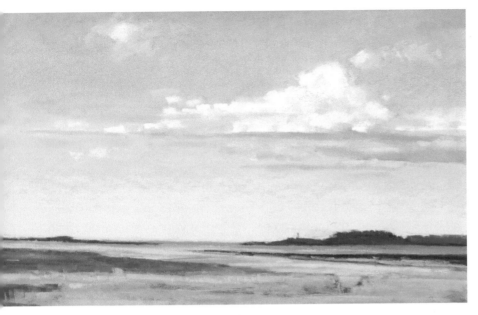

Summer Along Coastal Massachusetts, 1:00 P.M.

In the early afternoon, you can see the warmth from heat and humidity coming off the earth represented by the pinkish orange tinge of the sky down by the horizon. With increasing evaporation due to the hot summer sun, areas of cumulus clouds form. You will also notice fragments of cumulus fractus forming and evaporating.

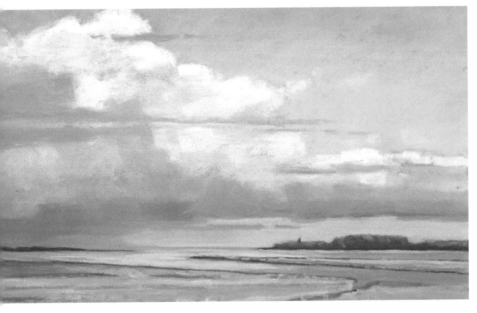

Summer Along Coastal Massachusetts, 5:00 P.M.

As the heat of the day continues, cumulus clouds have evolved into majestic rain-laden cumulonimbus thunderheads. Offshore there is rain. The angle of the sun is getting lower, giving more drama to the powerful cumulonimbus by creating shadow areas. Thin lines of velum clouds act as a horizontal counterpoint to the rounder shapes of the cumulonimbus.

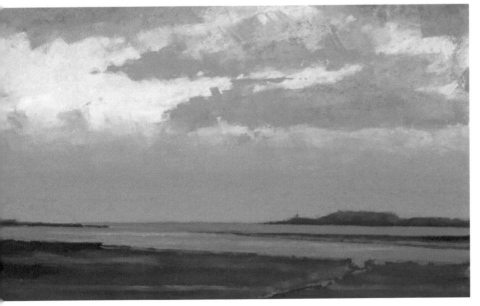

Summer Along Coastal Massachusetts Just After Sunset: Last Rays

As the sun sets, the cumulonimbus clouds retreat offshore, where they will dissipate and a few fractured stratocumulous clouds stray into the painting. Only the tips of the clouds are catching the last rays of light. These light areas take on a pink and peach tint because of the angle of the sun and amount of atmosphere that lightwaves have to travel through. Even the dark clouds take on a warm glow.

SUNRISE AND SUNSET—
TURN ON THE DRAMA

If you love to paint the sky, then sunrise and sunset can be transcendental. We live for these skies. I am guilty of quick stops and erratic behavior as I chase after a distracting sight. The world stops when nature puts on the best show on earth. This heightened color occurs when the angle of the sun is close to the horizon and light has to pass through a greater distance of low lying atmosphere. Clouds that appear ordinary during the day—when lit from above—become dramatic as their forms display brilliant hues lit from the side or bottom. The only problem for a painter is how fast sunrise and sunset happen. To paint from life, you need to be on site, preliminary work completed, with pastels in hand ready to commit quickly once the drama begins. Cameras are helpful, if not essential.

THE DIFFERENCE BETWEEN SUNRISE AND SUNSET

Much of painting the sky deals in subtle value and hue changes. This is obvious in the difference between sunrise and sunset. Although they can be difficult to tell apart, there are some slight indications that you can use to impart your painting with a time-of-day stamp. In addition to sunrises appearing cooler in color temperature, overnight can also bring with it a buildup of moisture in the form of dew. As this starts to evaporate with the arrival of the sun, it causes a haze to appear, obscuring land features and making distance appear milky. Knock your contrast down between the sky and land along distant horizons to achieve this appearance.

Sunrise, Sunset

Morning Sky has hazy distant landmasses. Although the rising sun has brought some peaches, pinks and yellows to the sky, they are toned down and appear cooler in contrast with the strong warm sunset colors of *Jubilee*.

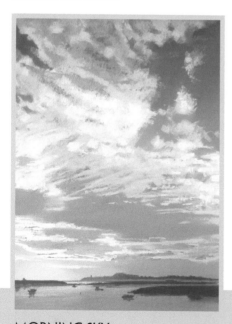

MORNING SKY
Pastel on Wallis museum-grade sanded pastel paper
30" x 24" (76cm x 61cm)

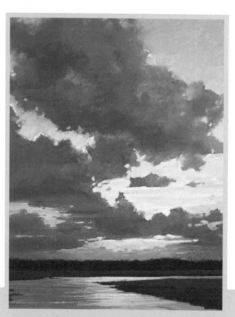

JUBILEE
Pastel on UART #500 sanded pastel paper
24" x 18" (61cm x 46cm)

Whoops!

When I am flying through a painting, sometimes the pastels also fly—right out of my fingers, shattering into pieces! I work with a rug under my easel, which does reduce breakage, but this is a universal hazard when working with pastels. Don't throw away the pieces. Get yourself a mortar and pestle. Grind up the broken pieces into a fine dust, discarding any foreign material that may have wound up in the mix. Save it in a jar to be used as underpainting pigment, washing it down with water or alcohol.

Or, you can create the most beautiful neutral-colored pastels by adding a bit of distilled water to the dust, using your mortar to mix it into a paste. Aim for the consistency of bread dough—not too much water. Form the paste into whatever shape you wish and when it dries you have a ready-to-use recycled pastel!

AMP UP THE COLOR

Painting sunrises and sunsets allows us to reach into our palettes and pull out those glorious, strongly pigmented hues that are the hallmark of the pastel medium: peaches, pinks, oranges, yellows and purples that are almost pure pigment with little modifier and just a bit of binder.

Partly cloudy skies are the most dramatic, with clouds colorfully lit by the last rays of light then turning dark and brooding as the sun disappears. A hallmark of these skies is that contrast is also amped up along with color, as clouds become dark while distant skies still contain light.

And while most artists think of sunrises and sunsets as always having exaggerated color, they are often muted with more subtle value and color changes. In *Day Before Tomorrow*, the late day sky is relatively gray because of the amount of cloud cover—with just a few touches of peach indicating clearer patches of sky. This smoldering, moody sky displays as much drama as a more colorful sky by using a limited palette and strong value contrast, which places the emphasis on emotion and mood instead of color.

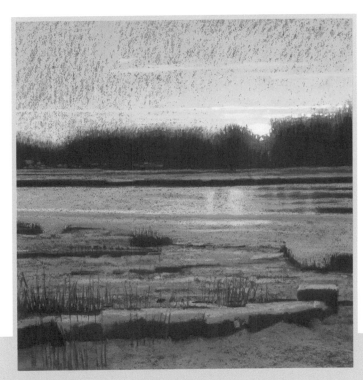

DAYBREAK
Pastel on Stygian black Canson Mi-Tientes paper
16" x 16" (41cm x 41cm)

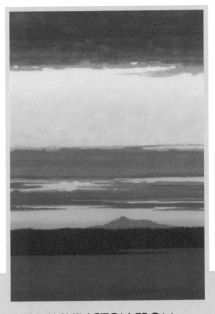

MT. WASHINGTON FROM LONG ISLAND, ME
Pastel on UART #500 sanded pastel paper
36" x 24" (91cm x 61cm)

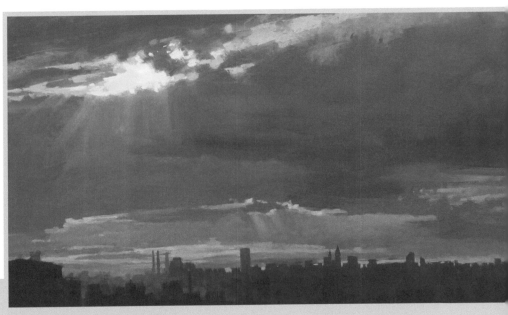

DAY BEFORE TOMORROW
Pastel on UART #500 sanded pastel paper
24" x 36" (61cm x 91cm)

PAINTING SUNSETS

This mostly cloudy sky image has wonderful diagonal movement in the clouds, which is what attracted me to the image. The colors are delightful and the sparkle of lights gives this cityscape a festive, upbeat appeal.

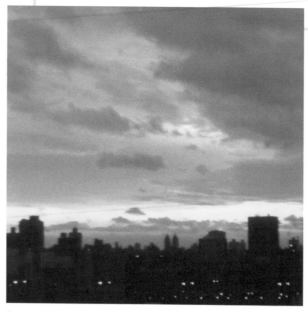

Source photo

Materials

PAPER

UART #500 sanded pastel paper

BRUSHES

2" (51mm) soft bristle housepaint brush, 1" (25mm) flat synthetic brush

PASTELS:

Light value: orange, peach, warm gray, cool gray

Midvalue: warm purple, warm gray-purple, gray-pink, grayish purple-pink, gray-red, warm gray, cool gray, slate blue, yellow ochre, red ochre, orange

Dark value: warm purple, warm blue, warm red, brown, warm gray, cool gray-brown, teal, warm and cool blues (cobalts, ultramarines and turquoises), warm purple

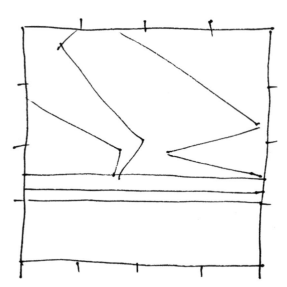

1 FIND THE GESTURE

Do a simple thumbnail to evaluate your cropping and image selection. Look for the gesture of the clouds in the sky, interesting massing and wonderful diagonals that direct your eye down through the clouds to the focal area, where the skyline hits the bright band of light. Find your focal area first and then make sure that the rest of the painting supports that focus.

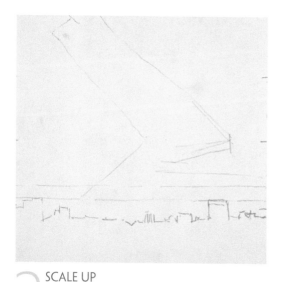

2 SCALE UP

Place your simple line gesture drawing onto your painting surface. Use crop marks to grid off both the source photo and your paper to assist you in putting the lines in the right spot.

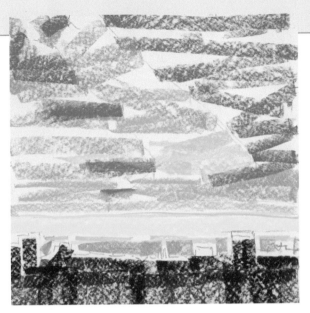

3 CHOOSE UNDERPAINTING COLORS

For the dark skyline, use a combination of dark values: warm purple, warm blue and warm red. Do not place them up to the upper edge where the sky meets the buildings; drag color up there with your brush later.

For the sky, choose values that will match the final value of each shape and that will lay underneath and peek through. A midvalue warm purple is good for the clouds, midvalue gray-pink and gray-purple-pink are good for the lighter cloud areas. Where the sun is brightest, use a midvalue orange to light value orange and peach.

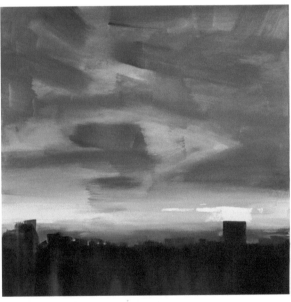

4 WASH DOWN

Since this is a large painting, use larger brushes, a 2" (51mm) soft bristle housepaint brush and 1" (25mm) flat synthetic bristle art brush. Begin with the light areas and lock them down, moving to the midvalue clouds next and the dark buildings last. Draw up the dark building shapes into the sky using the flat end of the brush. When dry, reevaluate your big shapes and look for the gesture in the clouds, making sure it's still there.

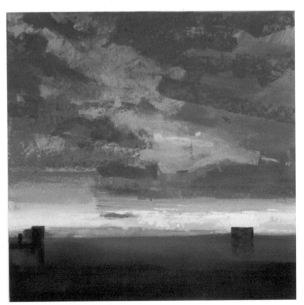

5 CHOOSE PAINTING PALETTE

Choose midvalues of warm gray, cool gray, warm gray-purple and slate blue for the clouds in shadow. Find a midvalue gray-red and yellow ochre for the light clouds. Use a light-value bright peach for the sunlit clouds along the light band. Several dark values will be needed to build up the buildings at the bottom: brown, warm purple, warm gray and cool gray.

Review the clouds, working to make sure your proportions are correct, and adjust the gesture you established in your first sketch.

6 FINISH THE BACKGROUND

Instead of drawing a dark outline of buildings, remember that when finishing a pastel, you finish what is farthest away first. Paint in the sky behind the buildings to make sure it is consistent from one side to another. Use your midvalue warm gray-purple for the sky. Draw the building shapes (negative space) by drawing the sky around the buildings. They will be the color of the underpainting, which is faint, but this works well to represent the more distant buildings as you build up the architecture.

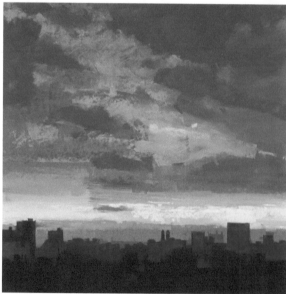

7 BUILD UP THE ARCHITECTURE

The buildings are the darkest value, so putting them in now will give you a value roadmap for the sky. Nothing in the sky should be as dark as the darkest buildings. Use the dark values of warm purple, warm gray and brown pastels. Draw with the pastel on its side to create chunks of color, overlaying strokes to create layers of buildings. If forms become too distinct, use your 1" (25mm) brush to blend them down a bit.

This area is not the focus. You don't want to paint it as one dark mass, but at the same time, you don't want to be painting a lot of detail; no windows, no distinct individual buildings.

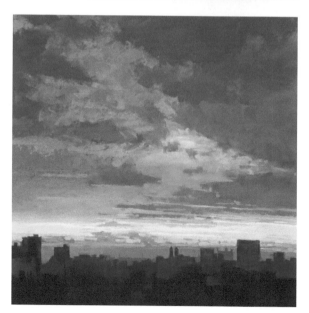

8 FINISH THE SKY

Use mostly the midvalue and light-value colors to finish the sky. At this point, put down the reference image and let the clouds become what they need to be. Keep an eye on the aerial perspective, making sure the clouds get smaller, flatter, closer together, and lighter and less detailed as they move into the distance.

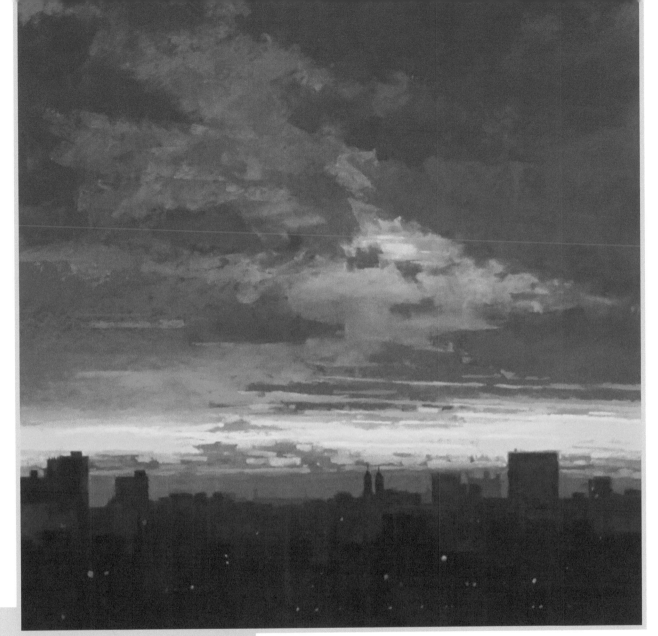

FIREFLIES
Pastel on UART #500 sanded pastel paper
New York City seen from the Amtrak train
24" x 24" (61cm x 61cm)

9 FINAL TOUCHES

Return to the buildings at the bottom and gently remove any light dust that has fallen. Make sure the architecture reads properly and correct any crooked lines. Put the antenna on top of the towers. Then place midvalue yellow ochre and red ochre dots to indicate city lights. Create smaller, darker dots farther away and larger dots closer. Place these lights sparingly, with varied size and density of color.

The Gesture in Clouds

How many times have you said, "I get lost when painting clouds, I can't find my place?" I hear it and experience it all the time. That is why the initial step of finding the gesture is so important. It's like visiting a new place and driving more than once over the roads—you quickly figure out where you are after a few passes.

You find the gesture in clouds by connecting similar value areas in clouds—creating bigger shapes. Once you find these big shapes, you will see the gesture. Is it sweeping upwards, sideways? Or is it leading your eye away from the focal area? If you can find the gesture, then when you get lost, you can always find your way back to the bigger shapes. Hey, I'm over here...

THE NIGHT SKY

There is a delicious mood and atmosphere to nighttime paintings. Colors glow brighter to show up on dark backgrounds. Direct observation is critical, because cameras find it very hard to reproduce the actual colors of night. If painting on location with a headlamp is not your style, then in addition to taking a photo, do a good reference sketch with color observation notes. Pay special attention to the value relationship between the sky and surrounding objects.

VALUE AT NIGHT

The primary challenge of painting the night sky is one of adjusting values. The night sky is going to be quite dark, but will be lighter than its surroundings. How much lighter depends on whether there is a moon. During a full moon, the illumination can be so strong that you can even see cast shadows, and the sky could be darker than the moonlit surroundings. The value range of a night painting will be greatly reduced, with the exception of bright lights, but even those should be toned down and not bright white. Look for the color in these brights. A helpful shortcut is to paint on dark paper so you don't spend a lot of time and pastel building up your darks.

SKY COLOR AT NIGHT

Colors are obviously muted at night. And between color and value, value is more important to get right. Colors look different at night, depending upon the source of illumination. This gives the artist great latitude in color choice, and just about any color can look realistic as long as the value is spot on.

Both of these studies of the setting moon are believable as nighttime because of the value relationship between the sky, moon and trees. But each hue carries its own interpretation. The dark blue sky tells us that it is a much clearer night without humidity. The dark red sky is just as believable, but has the feel of a bit of fog or humidity in the air.

City Nights

Night skies in the city are never truly dark. Light pollution is prevalent near any major town or city, and it isn't until you are in a very remote location that darkness is truly dark. *First Night From the Frogpond* is right in the middle of a brightly illuminated, nighttime Boston working on black paper. I used a combination of a dark, warm green and dark red-brown to create the sky. The red-brown concentrates towards the buildings, representing the upward glow of sodium-vapor lights. The warm green tinge higher up indicates fog with light bouncing around in it, including the bluish light from the windows of a nearby, fog-obscured high-rise building.

FIRST NIGHT FROM THE FROGPOND
Pastel on Stygian black Canson Mi-Tientes paper
19" x 24" (48cm x 61cm)

THE STARRY SKY

Stars appear randomly placed in the sky, and vary greatly in size and intensity. To deliberately attempt to replicate this randomness by hand is doomed to failure. Use the toothbrush technique instead. For this exercise, you will need an old toothbrush—the bristles are too rigid on new ones.

1 PREPARE THE SKY

Create the underpainting using mid- to dark-value red-purples for the sky and snow. Using dark- and midvalue cobalt, ultramarine and turquoise blues, render the sky. Leave some of the red-purple underpainting showing. Transition from lighter at the horizon to darkest at the top. Use the same midvalue blues in the snow below, adding some mid- to light value red-purple as highlights. Work the sky around the tree branches and then, using a dark brown hard pastel, define the branches and put some detail into the brush in the fields.

2 PUT IN THE STARS

This requires some practice. Use an old toothbrush and clean alcohol. Dip the toothbrush in the alcohol and then rub it lightly over a light blue pastel, picking up pigment onto the bristles. Don't use white; it's too light. Drag your finger over the toothbrush bristles to spray spots onto your paper. You will get a better spray pattern if you spray straight down. Concentrate your stars at the top of the painting where the sky is darker and stars are more visible.

Materials

Old toothbrush

PASTELS

Light value: red-purple, blue, gray hard pastel

Midvalue: red-purple, cobalt blue, ultramarine blue, turquoise blue,

Dark value: red-purple, brown medium to soft pastel, brown hard pastel, cobalt blue, ultramarine blue, turquoise blue

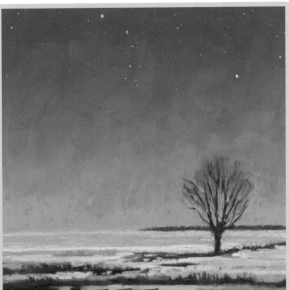

3 FINAL ADJUSTMENTS

Since this is pastel, remove stars you don't want with your finger. Correct any unwanted drips or spray patterns. To indicate a variation in star size and intensity, use a light-value gray hard pastel and handpick a few stars to highlight, which will also draw more attention to the sky above.

STARS AND SNOW
UART #400 sanded pastel paper
12" x 12" (31cm x 31cm)

MOONLIT SKIES

Night time does not record well, if at all. I rely mostly on my memory and a notated sketch, using a photo only for composition. Nighttime colors are so subtle and varied that, if possible, I'll return to my studio and paint immediately from memory before I've lost the image and its subtleties.

The moon appears so bright and luminous in the night sky—you will be tempted to use pure white but against the dark values of the sky, pure white will be too bright. Actually the moon is a bit darker—for instance we can see the man (or the lady) in the moon. Better to use a slightly warm yellow which is toned down from pure white. Your moon will glow with cool brilliance.

1 WORK ON DARK PAPER

No black paper is as dark as the darkest pastel, so you will still be able to use your very darkest hues. Use a very dark-value pastel to do your basic shape drawing. Never use a lighter pastel—you will not be able to eliminate the outlines. A rule of thumb in choosing your layout color is to use one that is slightly darker than the paper and just dark enough so you can see the lines.

Materials

PAPER

Clairefontaine Pastelmat, black

PASTELS

Light value: warm orange-yellow, warm yellow, warm white, no pure white

Midvalue: warm yellow-orange, yellow ochre, brick red, orange

Dark value: warm purple (several shades of dark), warm brown, turquoise blue, ultramarine blue, cobalt blue, brick red, gray purple, gray, brown

2 CHOOSE COLORS AND VALUES

Place the lightest light by putting a small area of warm yellow-orange where the moon is located. Do not fill it completely, just place a small amount in the center. Next, locate your darkest dark, using warm dark purple in the land masses at the bottom. Use mid- to dark-value brick red for the underside of the upper cloud, midvalue warm orange and yellow ochre for the clouds by the moon and several hues of dark-value blue and purple for the sky.

3 WORK ON SHAPES

Develop the shape of the cloud with dark-value gray pastel. Then start the glow around the moon and its reflection in the marsh. Lay in the first layer of marsh with the dark brown and the first layer of sky with dark turquoise. At the end of this step, you should have the first layer of pastel down over the whole painting. Now, you can evaluate your colors and values to make sure they are reading right before you commit to finish mark making.

4 DEVELOP THE ENTIRE PAINTING

Move over the entire painting, placing next layers of color down. Since the sky dominates, you can increase the interest by using several colors of dark-value purple, and dark warm and cool blues, layering them so the colors aren't blended but lay on top of each other and appear to vibrate due to the intensity of the hue.

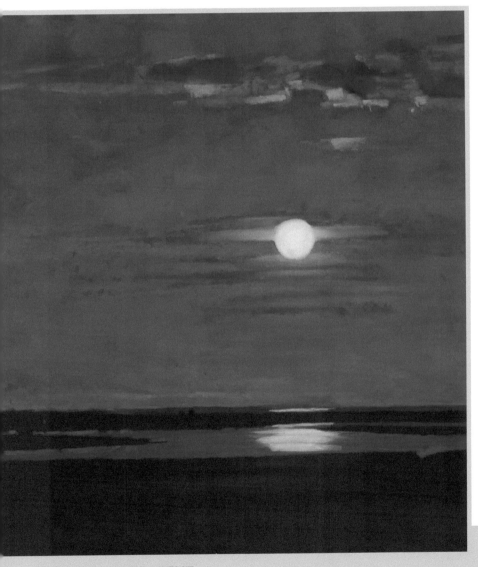

5 PUTTING IN THE GLOW AND FINAL TOUCHES

Finish the blue sky first with its layers of dark blues and purples. Work on the top cloud by bringing in the mid- and dark-value brick red to indicate moonlight hitting the underside. Likewise, develop the light on the cloud behind the moon. Use the midvalue brick red towards the outer edges and get brighter and warmer closer to the moon, using the midvalue warm yellow-orange, yellow ochre and warm orange. Take a little bit of the moon color and smear it from the moon outwards over all these colors.

Put the finishing touches on the reflection using the same colors you used for the cloud behind the moon. Use warm orange-yellow on the moon. Clean up the outside edge of the circle, put the light warm yellow in the middle and blend the edge and center so you don't see a line around it.

The last thing to do is finish the marsh. Use the warm brick red to create a few horizontal lines under the moon, indicating some cast moonlight on the marsh. At the edges, use the dark brown and dark warm purple to finish the marsh. This painting comes up quite quickly, all because of the head start using a dark paper.

JUST THE OTHER NIGHT
Soft pastel
16" x 16" (41cm x 41cn)

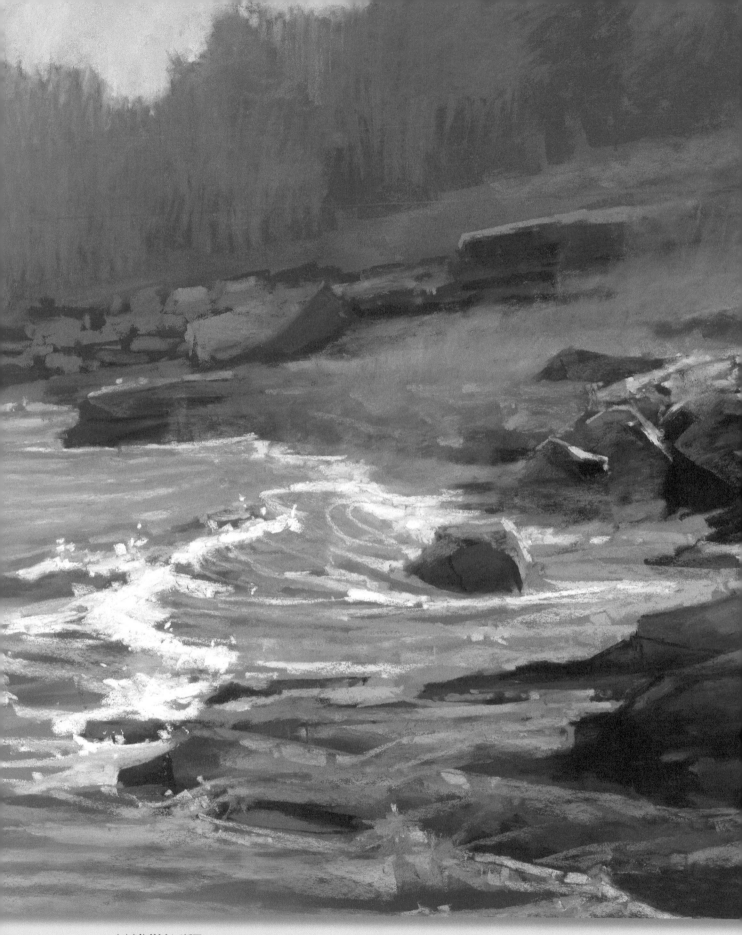

MAINLY MIST
Pastel on UART #500 sanded pastel paper
24" x 24" (61cm x 61cm)

Chapter Four
WATER IN THE LANDSCAPE

PAINTING WATER

Artists are drawn to water (pun intended). When painting the landscape, water elements are not only fun to paint, but their intriguing shapes can be used as effective compositional tools. A potentially sedate painting of a field could be enlivened by introducing a stream wandering diagonally across the foreground, leading your eye up into the painting. And water's reflective attributes bring additional dimension and serves as another source for aerial perspective.

THE COMPLEX COLOR OF WATER

Like the sky, water is not always blue. It reflects the colors above and adjacent, depending upon your eye level. To complicate things, water can be both transparent and reflective in the same image.

Four images taken of the Yellowstone River over a two-day span demonstrate how the color of the same body of water can appear vastly different. The water itself is brown due to flooding and sediment stirred up from springtime snowmelt. Despite the muddy water color, the first image shows a beautiful blue river because it is reflecting the bright blue sky above. In the second image, the day is cloudy and the river color is the reflection of the white sky, but where the current disturbs the reflection, you see the color of the brown water underneath. In the third image, the river reflects the gray of the cloudy sky above. The final image was taken near shallow water, revealing spotty bluish green moss clinging to the rocks. It also has a blue reflective cast from the sky and green reflected from the trees along the shoreline. Blue, gray, white, brown and green are all valid colors of the Yellowstone River, depending upon whether the river is reflective, transparent or translucent.

Blue water

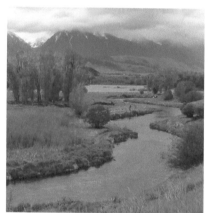

Gray water

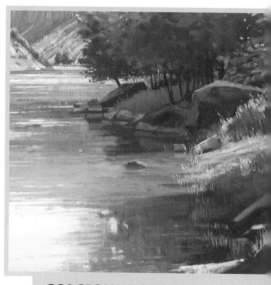

GORGEOUS MORNING
Pastel on UART #500 sanded pastel paper
18" x 18" (46cm x 46cm)

Beams of sun illuminate the heavily sedimented water revealing a golden brown tone. The reflection indicates a blue sky with clouds even though we can't see the sky itself. The river turns green where it reflects the trees and purple where it reflects the cliffs. Going all the way back, the river flattens, and pastel strokes get thinner and closer together. The color lightens to almost white where the currents disturb the surface, picking up reflected light from the sky.

White/brown water

Green water

HOW WATER BEHAVES

The most important thing to remember about how water moves is that, since it is subject to gravity, it will lie flat against the earth's surface. Even in moving water, you can find quiet eddies behind rocks where the water calms down and appears to lie flat. When water runs downstream, it will gather in flat pools before tumbling down to the next level.

This horizontal line is especially important where water meets the sky. Even in tumultuous seas, the far horizon of a large body of water, like a lake or the ocean, will appear straight and horizontal. This is why when you are seasick, you are told to watch the horizon to orient yourself—because the distant horizon of water appears flat, stable and unmoving. Painting a prominent body of water is one of the few times when I will take out a ruler and make sure that my line is not even off by an ⅛" (3mm) because this mistake is perceptible and will set the whole painting off balance.

At the ocean, not only is the horizon flat where the water meets the sky, but waves move in straight lines when heading into shore.

DIFFERENT BODIES OF WATER ALL EXHIBIT THE SAME TENDENCY TO FIND THE HORIZONTAL LINE.

The distant shore of large lakes will appear flat against their background.

In rivers and streams where water moves swiftly, can change levels and is visibly affected by currents changing the pitch and form of the water, the distant shore will stay flatter.

Looking down into moving water, calm eddies around rocks will appear flat and reflective in the chaos.

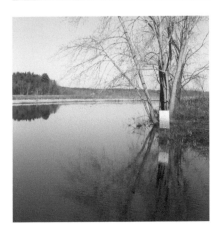

Calm water appears perfectly flat and reflective as if it were a mirror lying on a table.

PAINTING BELIEVABLE REFLECTIONS

One of the pleasures of creating artwork is painting reflections on water. It gives an artist the opportunity to practice some of their magic in bringing a two-dimensional surface to three-dimensional life. Successfully creating a wet-looking surface out of a dry medium is a real kick!

Reflections are key. Painting them incorporates all the things you have learned about simplifying shapes, creating distance, the flatness of water and painting what you see, not what you think. However, as much fun as reflections are to paint, they are difficult to do. And like improperly drawn perspective in buildings, if a reflection is wrong, it's wrong—even if it's off just a little bit. Hold your painting up to a mirror to get a fresh look at potential problem areas, or turn it upside down—both very helpful techniques.

THE MIRRORED IMAGE

Even after years of painting, I still can get a reflection wrong. The main concept is that the image is mirrored. It is easy if you have an element that is exactly straight, like a ships mast. In that case, your biggest challenge is to make sure that the reflection lines up directly underneath the object and is the same width and color. But if you have an object that is angled, then you need to mirror that angle exactly the same in the water, reversing the direction. It might seem an oversimplification to say "whatever appears above appears directly below," but to put it into practice isn't easy to do.

THE EFFECT OF CURRENTS ON A REFLECTION

Currents are water's equivalent of wind, creating movement in the water. As a reflection moves away from its source, it will degrade as currents, wind and waves disturb the water's surface. Strokes indicating current and water direction are the last thing you paint after establishing the correct location, color and value of the reflection. Follow this checklist when evaluating all of your painting's reflections:

1. Does the reflection line up directly underneath the object being reflected?
2. If the object is set at an angle, is the reflection reverse-mirrored properly?
3. Is the reflection the proper width and color?
4. Does the image degrade as it gets farther from the source?

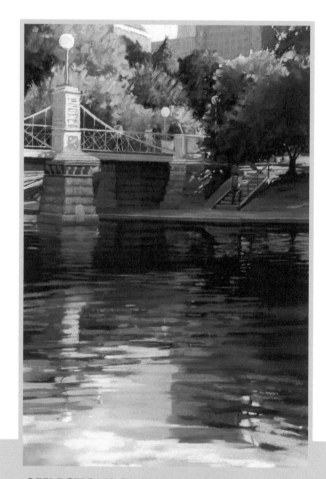

REFLECTIONS OF THE HANCOCK
Pastel on UART 500 sanded pastel paper
36" x 24" (91cm x 61cm)

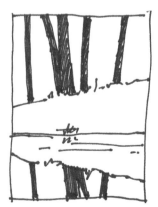

A common mistake is to continue the direction of an object right down into the reflection.

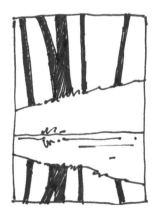

Correctly done, the angle will reverse at water's edge and mirror exactly what is above.

Download bonus materials at artistsnetwork.com/pastel-skies-water

REFLECTIONS ON FLOWING WATER

Wind, waves and currents all disturb the reflective surface of water, dispersing the image. A reflection will still be there, but in fractured pieces interspersed with other elements. This fractured reflection will maintain its basic shape, but sharp detail will be lost.

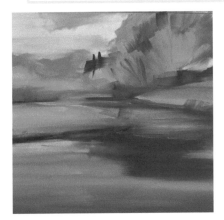

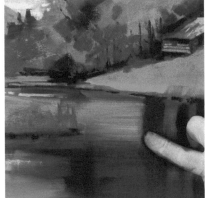

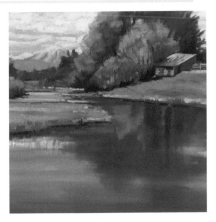

1 DEVELOP THE BASIC SHAPES

Establish the basic shape of the reflected trees in the water. Using a midvalue green-brown, place the exact color and value of the reflection in the water. Place a bit of the reflected warmth in the trees using midvalue yellow ochre.

2 ADD DARK REFLECTIONS

Work all over the painting to define the shapes and color, then turn your attention to the dark reflections in the river.

Place the dark reflections in the water directly below where they occur above. Use the same dark olive green in the shadow area in the trees. Now gently drag it into the water. Let the pastel get fainter as it goes farther down.

3 ADD GREEN TO THE REFLECTIONS

Work the top part of the painting to almost finish. Then bring some of the midvalue warm and cool greens from the trees down into their reflection. Use the same approach of lightly applying the color, then dragging it down slightly. Do not overly blend.

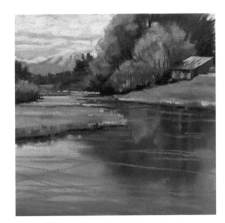

4 WORK UP THE CURRENT LINES

Work up the light sky reflections using light- to midvalue turquoise and cobalt blues that match the blues in the sky. Use a midvalue gray-turquoise to make the darker horizontal flow lines. The value of this color should appear light on darker areas and dark on lighter areas. Do not blend and don't overdo. The lines will be horizontal and thinner in the back, and can start to cross over each other and get thicker closer to the front.

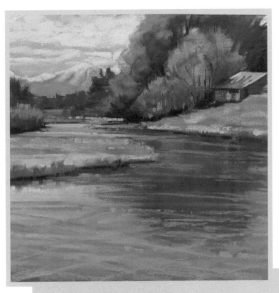

MONTANA ICONS
Paper on UART #500 sanded pastel paper
12" x 18" (31cm x 46cm)

5 FINISHING MARKS

Working over the dark reflection, use a mid- to light-value turquoise blue to develop a series of lighter current lines. Make thinner, straighter lines farther away. At the bottom of the painting, make the lines more agitated, creating diamond-like patterns. A handful of dots in a horizontal line will indicate a bit of sparkle. Pump up the color with midvalue turquoise for a few final lighter lines.

REFLECTIONS ON CALM WATER

The reflections on calm waters can be as sharp as if seen in a mirror. An artist needs to pay close attention to detail and be precise in the placement of shapes. It will be as if you are painting the same image twice. This is where using a trick such as turning your painting upside down to work out fine details will help. Edges will be sharp in the reflection, colors will match and the image will hardly degrade. The only indication this is water will be the marsh grass and handful of current lines placed at the very end.

Materials

PASTELS

Light value: gray-blue, warm gray, warm white, peach, red ochre, yellow ochre

Midvalue: gray-blue, warm gray, orange, warm olive, red ochre, yellow ochre

Dark value: warm olive, red ochre, yellow ochre

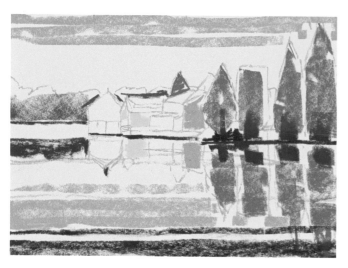

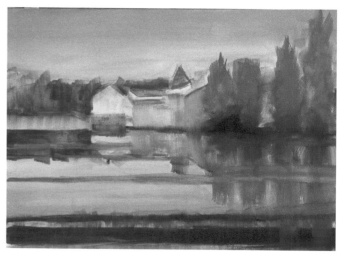

1 CORRECT DRAWING
When placing the drawing and colors for your underpainting, make sure you have placed the basic shapes in their correct locations and in proper proportions. Do this for both the buildings and trees and their reflections below.

2 WASH DOWN UNDERPAINTING
While washing down the underpainting, you have the opportunity to start to get the impression of reflection by dragging the wet pastel with your brush in the direction and shape of the reflection. Make sure shapes reflect each other. Some horizontal lines are drawn indicating where marsh grass interrupts the reflections.

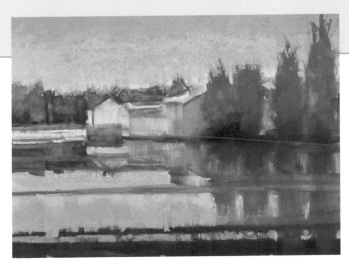

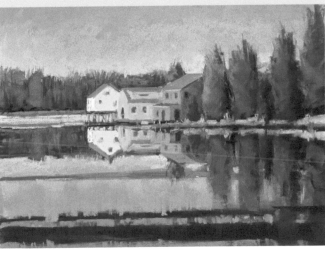

3 PLACE THE VALUE AND SHAPE

Select three close value pastels of gray-blue from midvalue to light value and render the first layer of sky and water. Keep in mind the transition in value, which reverses in the water with the darkest values at the top and bottom of your painting. Do not fill in the tooth; allow some underpainting to show through.

4 DEVELOP BUILDINGS, TREES AND THEIR REFLECTIONS

To reflect the color of the setting sun, choose colors in a warmer range. A cool gray becomes a warm gray, the white house picks up a peach hue, the trees have midvalue orange overlying a midvalue warm olive green. Render the buildings and trees as exact mirrored reflections. Part way through, flip your painting and work upside down to catch inaccuracies.

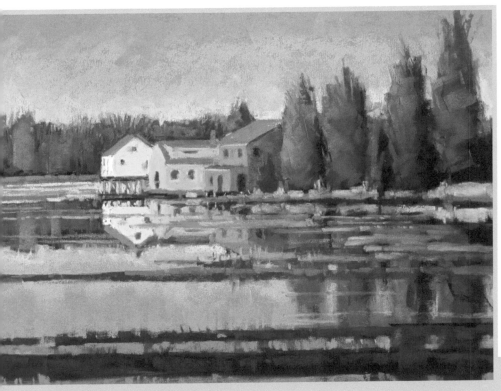

5 THE FUN PART!

Now play with breaking up the reflection by drawing the pieces of marsh and a few current lines. Using red and yellow ochres from dark value to light value, draw the horizontal patches of marsh grass poking up through the water. Draw right over the building reflections. Put the darker values down first and add the highlights on top. As the patches of grass get farther away, apply rules of aerial perspective so they get thinner and closer together. A few small, light gray-blue horizontal current lines will add the feel of motion in the water. Use these minimally because this water is essentially dead calm.

MACOMBER'S RIDGE REFLECTING
Pastel
12" x 18" (31cm x 46cm)

PAINTING RIVERS AND LAKES

Paintings containing rivers and lakes have an intimacy that paintings of the vast ocean do not. The relative close proximity of landscape elements like trees, mountains and buildings offers the potential for interesting reflections. And because these bodies of water are surrounded by land, they can have dramatic shapes that make for dynamic, lively compositions. With these juxtaposing land forms around rivers, lakes, streams and creeks, you need to make sure that the aerial perspective in your initial drawing is correct and the shapes lay flat and recede convincingly.

USING WATER TO DEPICT MOOD

In both paintings, the water embodies the mood; one peaceful and reflective, the other one full of movement and change. The intimacy in *Herring Run* invites the viewer to wander in and pause. Yet despite being sheltered by the trees, the background contains a bit of mystery as to what lies beyond. The stream is so near that you can see that it is brown because sunlight is illuminating the mud under the clear water. The foreground shadow turns the stream into a mirror reflecting the background trees.

The less intimate *Riverside Landing* makes a bold statement with its heightened sense of drama and depth of aerial perspective. Because of the greater distance, dramatic light and use of strong complementary colors, it catches your eye from across a room. The clouds offer clues to the weather by indicating a front passing through with the river's agitated surface indicating a strong breeze. The water's broken surface reduces its reflective ability, allowing only the general color of the passing cloudbank above.

LAYERS OF TRANSPARENCY

Painting water can be quite complicated. You have subject matter under the water, the water itself, reflections from surrounding landscape elements, reflections from the sky, currents, ripples and dancing spots of light. What do you paint first? A helpful way to approach such a complex subject is to paint using layers of transparency.

HERRING RUN
Pastel on UART #500 sanded pastel paper
20" x 20" (51cm x 51cm)

RIVERSIDE LANDING
Pastel on UART #500 sanded pastel paper
24" x 24" (61cm x 61cm)

LAYERS OF TRANSPARENCY IN WATER

When layering a landscape painting, you always start with what is farthest away. In this case, you are working with a subject whose depth is measured in feet, not miles, and you can see back and forth through the layers. A water painting will usually have 3-4 layers of transparency. In this demonstration, the painting has the following three:

 Bottom layer: ground under the water with mud, stones and shadows from trees

 Middle layer: reflections on top of the water from surrounding trees and sky

 Top layer: ripples disturbing the reflections

This painting is all about delayed gratification. The majority of painting time is spent methodically building up these deliberate layers of transparency until you place the reflected light on top. If you are able to hold off on that lightest layer until the end by carefully building the foundation underneath then applying the last layer is thrilling as the whole painting magically comes to life.

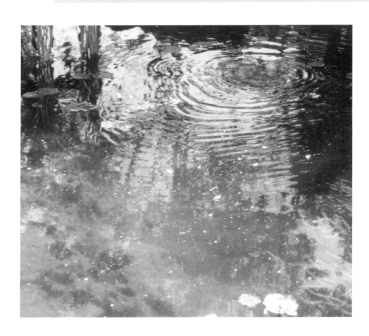

Materials

PAPER

 Pastelmat, maize color

COLORS

 Light value: cobalt, turquoise, ultramarine, yellow ochre, warm green

 Midvalue: gray turquoise, gray-green, cobalt, turquoise, ultramarine, yellow ochre, warm gray-yellow, warm brown-gray, warm brown, grass green, red ochre, warm gray-purple

 Dark value: cool brown, warm purple, gray-green, gray turquoise, cobalt, turquoise, ultramarine, warm brown, warm red-brown

1 DO SIMPLE SHAPE AND VALUE SKETCHES

Start with a simple shape sketch to locate the focal point in the center point of the ripple. Do a second sketch, applying value to the simple shapes. In this case, the painting breaks down into three value shapes: the dark value shadow area at the top, the light value band of reflected light and the midvalue of the pond at the bottom. By doing the value sketch you can see how the focal area is cradled by dark areas that support it and keeps your eye from wandering off the nearby edges.

Working with Colored Paper

An effective and easy alternate to doing an underpainting is to work on a colored paper. Colored papers lend a painting the emotion that their color embodies. If you have a cool winter scene that you wish to warm up, you could choose to start with a warm orange or yellow paper. To enliven a foggy day use magenta, pink or peach paper to give life to the grays you will paint on top. Many artists choose to work with a paper toned with a middle value allowing them the enjoyment of building up both the darks and the lights as opposed to just developing the darks as you would on pure white. You can purchase pre-colored paper or create your own. I like to tone white paper, using artists inks which have strong hues but are thinner than paint so they don't fill up the tooth. Explore using colored paper to give a new attitude or direction to your painting.

 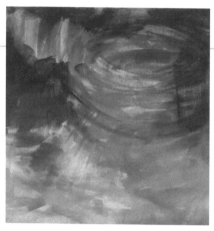 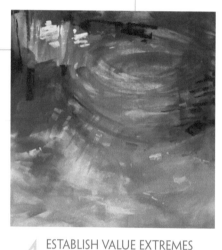

2 CHOOSE UNDERPAINTING COLORS

Transfer your drawing to your painting surface, then choose the bottom layer of colors that appear underneath all the layers. You will be establishing the dark shadows and the colors of the bottom of the pond under the water. Use a dark, warm purple for the very dark shadows. Pick a dark value gray-turquoise and dark gray-green for areas under the focal point and under the reeds. Use a midvalue gray-turquoise and midvalue gray-green for the light, diagonal simple shape. Finally, choose a midvalue yellow ochre for the bottom of the pond and a midvalue gray-brown for the shadows that appear on the bottom of the pond.

3 WASH DOWN

Start with the lightest color—the yellow ochre—and wash down the pastel underpainting. Use a 1" (25mm) flat wash brush so you make large strokes and don't get caught up in the detail. Refer closely to your reference image. Moving onto the darker colors, start to blend the shapes a bit. When washing down the dark purple, make an indication of the ripples around the focal point, dragging some of the purple over the midvalue gray-green. When done, there should be no dry pastel left and the simple shapes you started with have softened and blended together. Evaluate and make sure you can still see the gesture and composition you established in your earlier sketches.

4 ESTABLISH VALUE EXTREMES

Place your lightest light, a light value warm blue in the water reflection to the upper left. And in the same area, place a bit of the darkest dark, warm purple. These are your value extremes.

By making small, careful marks on different value and color areas of the underpainting, select the pastels you will use and set them aside.

Making Mistakes

We all do it. Notice that between Step 5 and Step 6 I have moved my lightest light location. I put it in the wrong place and if I didn't correct it, then the gesture of my painting would be wrong and it would throw off my whole composition. I put my lightest light in a dark area so I can't brush it off or wash it down because it will leave a light blue cast where I want it to be orange. My solution is to take the painting outside, put on a mask, and use a can of pressurized air to blast away the offending pastel. Works beautifully and I can get pretty close to back to the original underpainting. Do not do this inside!

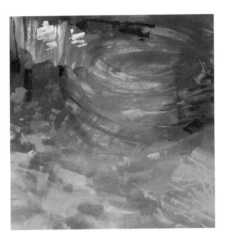
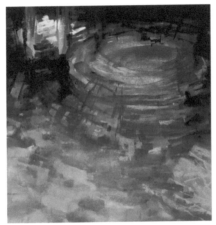
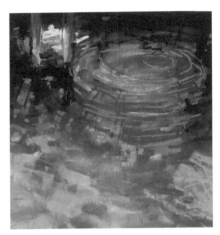

5 START WITH THE BOTTOM LAYER

When painting layers of transparency, start with the farthest areas, in this case the bottom of the pond. After all the hard work to get the underpainting colors and value correct, be careful to allow those colors to show through. Work on this very first layer should be minimal. Use the following midvalue colors to develop the light and shadow pattern on the pond floor on the lower half of the painting: yellow ochre, gray-green, warm gray-yellow, warm brown-gray.

6 WORK THE MIDDLE LAYER

Work on the shadows on top of the water. This gets tricky because the work underneath the water is done. Don't cover up much of the work done in the midvalue area of the painting, which is the shadow area on the water and shadow area under the ripples.

Develop the darker shadows at the top. Add some transitioning midvalue gray-turquoise around the ripple center and as the reflected tree trunks coming diagonally from the ripples. Use a bit of midvalue warm gray-green in the lower right quadrant to develop the shadow of the tree foliage on the water.

7 DEVELOP THE TOP LAYER

Develop the last layer of the reflected light on top, but don't throw down your very lightest light. Make this light layer from several blues of different values. Do a first pass using only a midvalue gray-turquoise-blue that acts as an underlying base for the lightest blue in the focal area. It also works as the light spots around the reeds and as the outer ripples on the right.

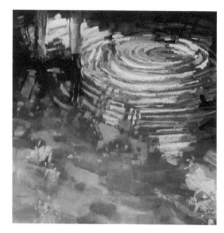

8 PLACE THE RIPPLES

Using your lightest lights in a range of light blues, place the light ripple rings. Be sure to keep the ellipses correct. A practice in your sketchbook will help you feel these ripple ellipses before you commit to painting them. Don't overwork them! These are not easy to correct, due to all the work built up underneath.

Vary the line quality, as some ripple lines are thicker and some thinner. As you move out from the center of the ripple, the reflected light blue gets slightly darker and the ripples less pronounced. Remember to keep an eye on the simple shape for this value established in your first sketch. Scumble blues lightly over the similar value yellow ochre of the bottom of the pond to reflect the sky holes from the trees.

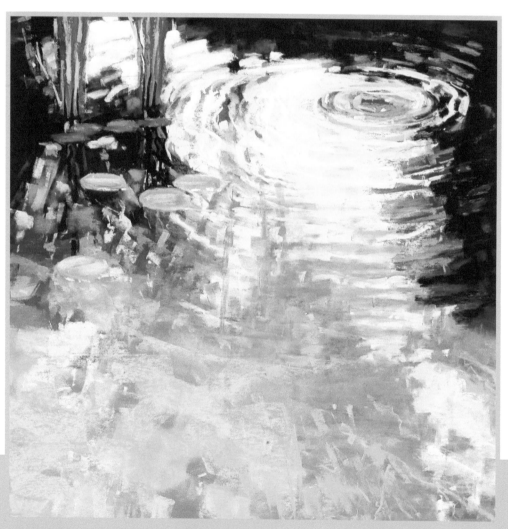

9 FINISH THE REEDS AND A FEW LILYPADS

These are the very last items to paint since they sit on top of the pond. Now that the supporting dark pond background is done, finish the reeds with a darker and midvalue grass green. Highlight them with a lighter value warm green. A bit of midvalue red ochre gives interest to the stem base. Add a few lilypads, using a midvalue warm gray-purple and a slightly lighter warm brown for highlights.

REEDS, RIPPLES, AND REFLECTIONS
Pastel on Pastelmat, maize color
20" x 20" (51cm x 51cm)

CAPTURE MOVING WATER

After working deliberately and consciously to build up layers of transparency, we build the final layer, indicating movement. These final light marks can be directional lines indicating currents or the scumbled froth at the top of a wave or from the tumble of a waterfall. But they are always the very last marks to be placed—so you need patience, vision and the ability to delay gratification to tackle this subject!

1 UNDERPAINT

When underpainting water, lay in the darks underneath. Carefully evaluate the color of these darks in the water, which are the underside of waves. Get those colors and values right and the painting will never get muddied. Use midvalues and dark values, no light values, of warm blue, red ochre, brick red, brown, brown-orange, yellow ochre.

Materials

COLORS

Light value: cobalt blue, turquoise blue, ultramarine blue, yellow ochre, red ochre, brown, warm white, hard white, warm gray, cool gray

Midvalue: cobalt blue, turquoise blue, ultramarine blue, red ochre, brick red, brown, brown-orange, warm brown, yellow ochre, gray-orange, orange, warm gray, cool gray, olive green

Dark value: cobalt blue, turquoise blue, ultramarine blue, red ochre, brick red, brown, brown-orange, brown-red, yellow ochre

2 WASH IT DOWN

Using a wide flat brush—a combination of ¾" (19mm) and 1" (25mm) works well—wash down, moving with the direction of the water. In the grasses, brush vertically. In the middle pools of water, blend the colors smoothly side to side. Vary your strokes for the largest area of blue, agitated water and flow them diagonally with the water direction. If you have the right value and color, some of these strokes can show through in the final.

3 WORK UP PALETTE

Select the correct pastels that will make up the palette for your painting and set these aside. This painting is mostly in the midvalue range, with the exception of a few darks in the grasses, rocks and under the currents. On the lighter side, use light-value yellow ochre and browns in the grasses and light-value browns and warm white highlights on the rocks. The lightest blues are a mid- to light-value, but use a brighter blue than one with white added.

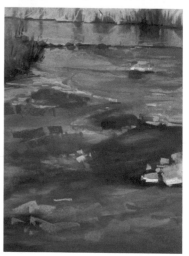

4 DEVELOP THE GRASSES AND UPPER POOL

Work on the upper pool and the grasses lining the bank. This pool is highly reflective, at eye level and with only a few visible current lines. As a result, what appears above needs to mirror exactly below in the reflection. Use dark-value brown to anchor the grass at the shoreline. On top of the dark brown, work in the other grass colors. Use these same colors in the reflection but reduce the detail. Don't cover up the underpainting completely.

Build up the clump of grass on the upper left between the upper and middle pool with the same grass colors. Don't apply the highlights yet.

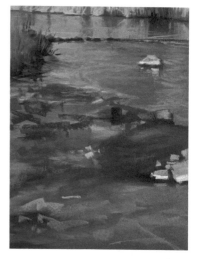

5 WORK THE MIDDLE POOL

Represent the increased movement in the middle pool with obvious current lines that show up as midvalue blue marks on the base of midvalue brown, orange and red ochre. These movement lines follow the direction of the water and lead your eye to the water tumbling down into the stream below.

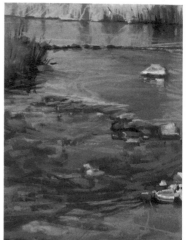

6 THE BOTTOM STREAM

Using a range of mid- to dark-value blues, as well as midvalue red ochre, warm gray, warm olive green and warm brown, develop the rushing water in the bottom stream. Work on the color of the water itself. Do not cover up all of the underpainting. Place your marks vigorously, moving in the direction and gesture of the current. Vary the stroke length and thickness, dipping and moving around the rocks. Use directional lines to indicate the movement of the water if needed.

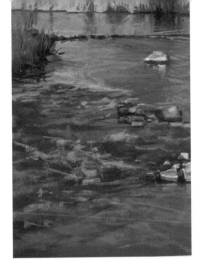

7 FIRST PASS AT WHITEWATER

Soften the detail of the waves by blending in some of the areas with a harder pastel of midvalue blue-gray on its side. Then pick up a midvalue warm gray and draw in the first pass of the whitewater. Try to get the movement of the splashes and aim for the proper location and shapes. Use a midvalue peach to capture the reflected light in the water of the rocks on right. Use the same color to indicate light dancing off some of the waves below the rocks.

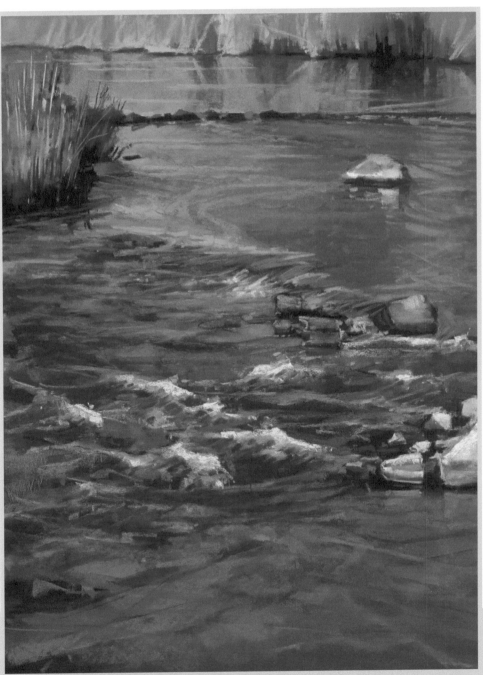

8 ADD HIGHLIGHTS

Now place in all the highlights. Starting with the water, take a light-value warm white and dance it across the tops of the gray waves, indicating the light hitting the very tips. A hard white pastel can be used to connect some of the white shapes and blend the white and gray together. A light-value yellow ochre and red ochre are placed in the grass clump at the upper left. Use the pastel on the side and drag it to make sharp spikes. Touch up some of the horizontal current marks on the two upper pools using a light-value brown and midvalue blue.

MOVING COMPLEMENTS
Pastel on UART #500 sanded pastel paper
27" x 21" (69cm x 53cm)

FALLING WATER

Whether out for a hike, or searching for a subject to paint, waterfalls are a popular destination. The iconic waterfall offers the artist drama, beauty and the challenge of attempting to capture the sound and force of movement on a two-dimensional surface.

Materials

COLORS

Light value: warm white, gray-white, yellow ochre, ray pink, tan, warm gray-purple, cool gray, gray-turquoise

Midvalue: yellow ochre, yellow green, olive green, gray goldenrod yellow, gray-turquoise, red ochre, brick red, warm tan, yellow-orange

Dark value: warm purple, gray-green, turquoise, gray-turquoise, cool brown, warm brown, brown, red-brown, red orange, red ochre

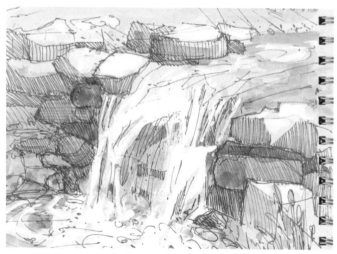

1 WORK FROM A REFERENCE

Keep a sketchbook with you at all times to employ small bits of time to work on your observational skills.

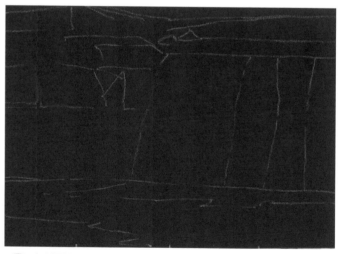

2 WORK ON BLACK

Start with a dark surface when your subject image is more than 50% dark. Transfer your simple shapes to dark paper using a light hand and a darker pastel.

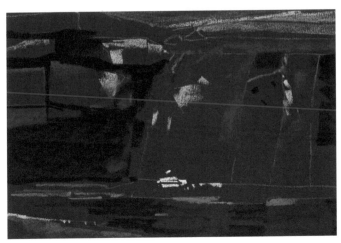

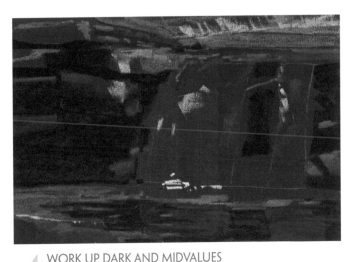

3 PULL OUT YOUR PALETTE

Establish your darkest value with a dark warm purple that is actually darker than the paper. Place it in the shadow areas of the rock wall. Put a few small marks of a warm white at the base of the waterfall, so you know how light this area will eventually be. When working on dark paper, you cannot erase or remove misplaced lights, so build them up slowly, making sure you nail the value and location.

Pull the colors you want for the rest of the painting.

4 WORK UP DARK AND MIDVALUES

Start layering in the dark value and midvalue masses. Place dark value brown, and dark warm purple on the wall to the left defining the dark shape. Also place them in the water at the bottom, where they lay under the reflections. Build up the stream above the waterfall using midvalues of yellow ochre, goldenrod yellow and warm tan. A midvalue red-brown can be used as a base color for the sunlit areas of the rock wall as well as in the sunlit water above and below the waterfall.

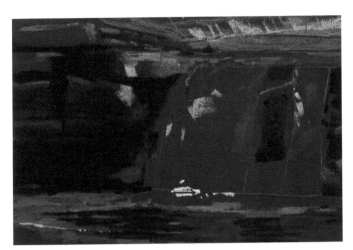

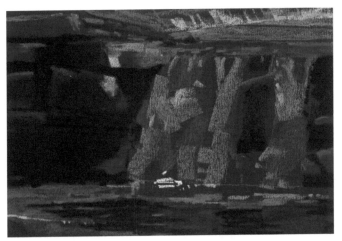

5 WORK ON THE ROCK WALL

Using all dark-value colors: dark red ochre, dark brown, dark warm purple, dark gray-turquoise and dark warm brown, complete the stonework in the rock wall. Use the darkest dark to draw the rock shapes and for the deepest shadows. Use the warm, brighter brown on the top rocks as reflected light bouncing up from the lit water below. Take note that all these colors are darker in value than the black paper you are working on!

6 CREATE SIMPLE SHAPES IN WATERFALL

Look for the value shapes underneath the bright highlights of the waterfall. There are areas where the light water contrasts strongly with the darks underneath, but there are also midvalues where the contrast is less obvious. Setting up this variation of values underneath the waterfall will make it look more believable. Use a midvalue gray-turquoise for the darker shapes and a slightly lighter value of the same color for the lighter shapes. Use the side of your pastel to place these strokes.

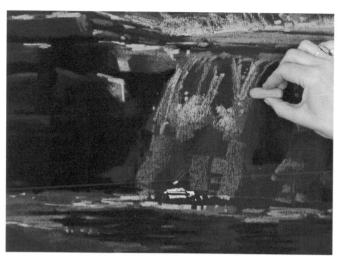

7 THE COLOR OF WATER

Use a warm gray midway between a midvalue and light value to start bringing up the lights in the waterfall. Start to build up the movement marks that sit under the final bright value. Use the tip of the pastel and go right over the shapes established in the previous step. Place this same color on the flat water at the waterfall base and use it to bring up the sunlit areas on the rocks to the upper left. Where the water spills over, use a midvalue gray-turquoise to make peripheral splashes along the sides and darker areas of the waterfall.

8 THE SECOND LAYER OF LIGHT ON THE WATERFALL

The first layer broke the waterfall into shapes using the gray-turquoise. Now select a light-value grayed white and place movement lines and indications of where the water is hitting rocks and creating splashes. Also use this at the base of the waterfall where the sunlit, agitated water settles into the pool.

9 ADD THE FINAL SPARKLE

Add the brightest value highlights on the waterfall. Use sparingly, letting much of the underlying layers show through. Use a light-value warm white to create dots of bright splashes. Use it at the bottom of the biggest fall, the one on the left. Don't develop all three major falls equally, one should dominate. Use this warm white to spill into the pool at the bottom, but again, use it sparingly. The final check is to make sure that the reflection in the pool below is the mirror image of the waterfall above with correctly positioned light and dark shapes.

WHITE WATER FALL

Pastel on Stygian black Canson Mi-Tientes
12" x 18" (31cm x 46cm)

PAINTING THE OCEAN

The ocean speaks to artists in the same way mountains do. Its immensity and vastness is so overwhelming that it has the ability to stop us in our tracks and restore perspective to our lives. It's no wonder creative people have always tried to capture the ocean's grandeur and sense of endlessness in words, music and paint.

THE DISTANT OCEAN

Unlike mountains, which have massive undulating forms, the distant ocean is relatively featureless. Its greatest characteristics are its lack of form, its flatness regardless of the height of waves and its reflective qualities. Reflections in the ocean are never as distinct and sharp as you would get in a calm pond but are always broken up due to ever-present waves and currents. The ocean's distant horizon will always remain flat despite obvious whitecaps and crashing waves along the coastline. Use the following aerial perspective principles to create distance when painting distant ocean.

- Linework representing currents and waves will get thinner, closer together and go out of focus as waves recede.
- The color and value of the water will transition from near to far, the extent determined by light and weather conditions.

Where the ocean picks up real interest is when it interacts with the shore: rocks, sandbars and beaches create waves and movement. Tidal action means the ocean is in constant motion. This is hard to see in the distant ocean, but this movement characterizes the shoreline. The shore can be calm with lapping waves as seen in *Eventide* which is on a calm summer evening at low tide, or it can be very dramatic with curling, crashing waves as in *The Sound of Sea Mist*. Reflections along the shore are fascinating to paint especially along the edge of receding waves where the wet sand briefly catches reflected color from the sky above.

≪ **EVENTIDE**
Pastel on UART #500 sanded pastel paper
12" x 36" (31cm x 91cm)

SOUND OF SEA MIST
Pastel on UART #500 sanded pastel paper
16" x 32" (41cm x 81cm)

Reflections on the ocean are indistinct and broken up by waves and currents.

When painting waves, work to build up the layers of transparency, looking carefully at the differences between the color of the water in a wave versus the color of the water in the troughs in front and behind. Pay special attention to the change in color towards the top of the waveface, near the lip where the water thins out and becomes more transparent. As with all water, you need to build up all the colors underneath before placing the lightest spots of sea spray and seafoam on top.

Materials

COLORS

Light value: gray-green, gray-peach, bright orange, warm peach, warm white

Midvalue: gray-turquoise, olive green, warm brown, yellow ochre, cobalt blue

Dark value: olive green, bottle green, warm brown, turquoise, cobalt blue

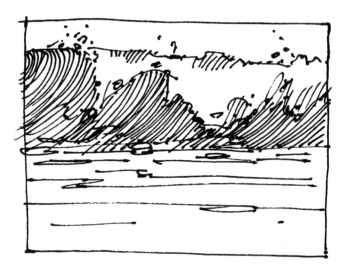

1 GESTURE OF THE WAVE

Make several sketches to get the flow and gesture of the specific wave you wish to paint. This will familiarize you with the feel and movement of the water. The wave evolves out of the trough in back and will curl up off the surface of the trough in front.

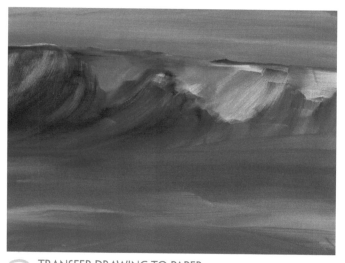

2 TRANSFER DRAWING TO PAPER

Do a simple shape drawing, and scale up the drawing to your paper. Choose underpainting colors and values to match the water under the whitewater. Wash down and let it dry.

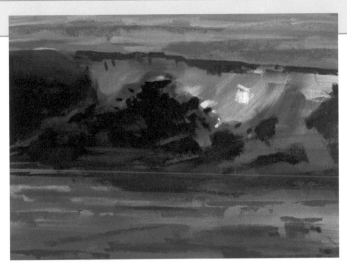

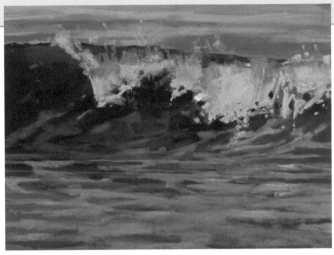

3 BUILD THE BOTTOM WATER LAYERS

Paint in the actual color and value of the darker water under the lip, face and barrel of the wave, also under the wavelets in the troughs in front and behind the wave. Use dark-value olive green, bottle green, warm brown, turquoise and cobalt blue. As you move along the wave face to the right, transition to midvalue olive brown-green where reflected light brightens the face. Some midvalue gray-turquoise and cobalt blues are used in the troughs. The trough behind the wave is lighter in value with less detail than the trough in front of the wave.

4 SEAFOAM AND REFLECTIONS

Using values that are dark lights, ones that are just a bit lighter than midvalue, develop the seafoam. Choose a light gray-green, light gray-peach, bright orange and warm peach for colors of the seafoam on the wave face. The seafoam is lighter on the right side where there is a bright reflection off of the curling wave. This reflection is also cast into the trough in front of the wave so use the same dark lights to draw diagonal marks intersecting horizontal marks creating diamond-shaped patches of seafoam. Use the light gray-green to put the first layer of light on the cresting wave, placing some splash marks up into the air above.

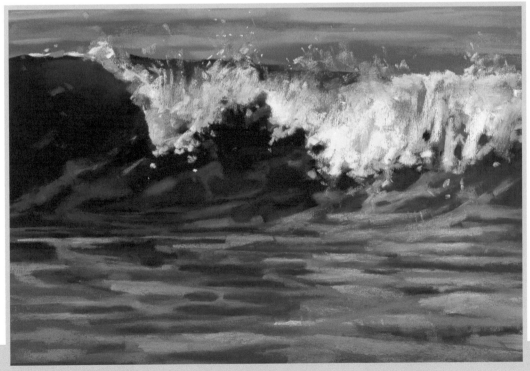

5 SEASPRAY

The final step is to place the very lightest value of seaspray on the cascading wave. After building up the darker lights underneath, you don't need to overdo these final highlights. Using a warm white, not a cool white, work along the edges of the light shapes rounding them and giving volume to the water. Use the same warm white to scumble some spray up into the air above the wave.

A NICE LITTLE CURL
Pastel on UART 500 sanded pastel paper
12" x 16½" (31cm x 42cm)

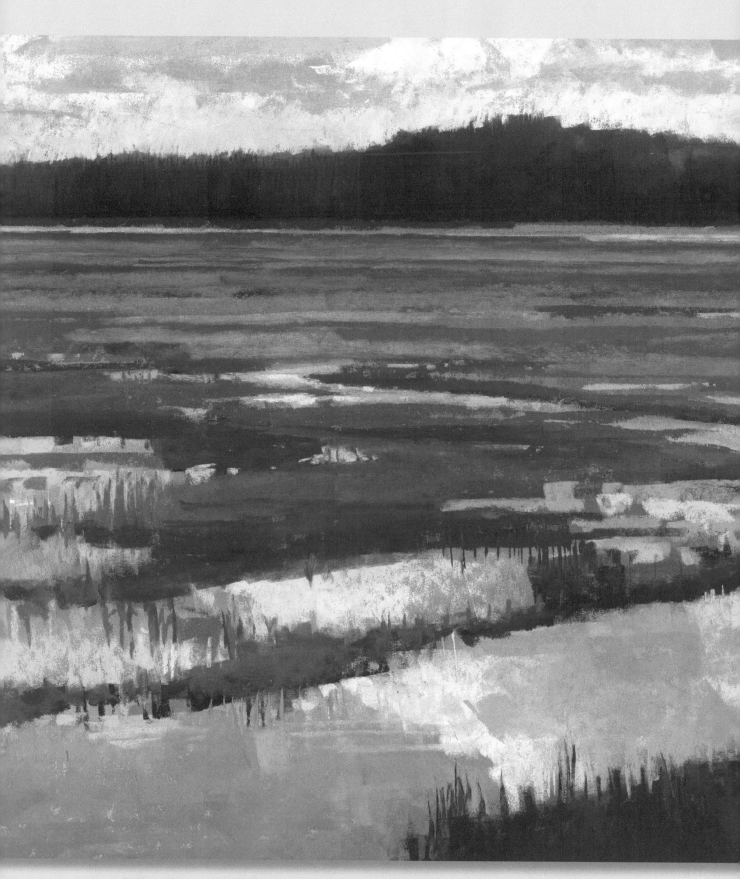

SHIMMER
Pastel on UART 500 sanded pastel paper
15" x 30" (38cm x 78cm)

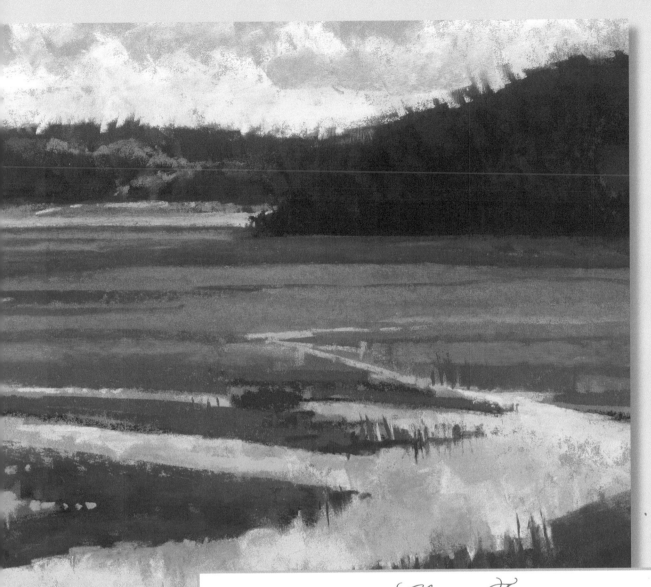

THE INTEGRATED LANDSCAPE:
SKY AND WATER

THE SKY IN WATER

The relationship between sky and water in landscape painting has many manifestations. The most obvious is when the sky is reflected in a body of water. But this also includes atmospheric conditions where water is suspended in the air as haze, humidity, rain, fog or snow. We will explore all of these situations in this chapter along with a bonus section, where I describe to you my techniques for painting trees against the sky. When the sky is reflected in a body of water, these are the factors you need to apply:

• Whatever appears above will appear directly below in mirror image
• The value transition in the sky both above and reflected below the horizon gets darker as you move away from the horizon
• Use careful observation of values because often, the reflected image is slightly darker and the values are closer together
• In the reflected image, the farther you move down and away from the horizon, the reflection will start to degrade due to movement in the water from currents, wind, etc.

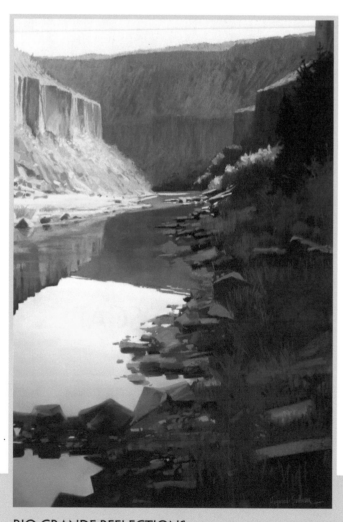

RIO GRANDE REFLECTIONS
Pastel on Wallis sanded pastel paper
36" x 44" (91cm x 112cm)

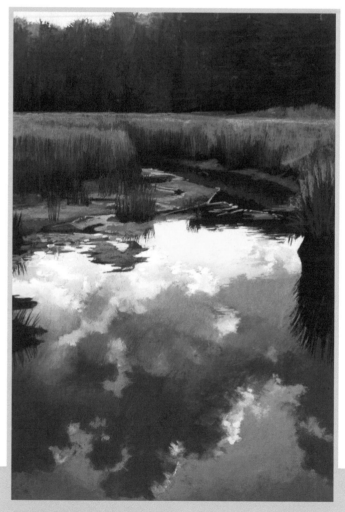

REFLECTIONS OF THE DAY
Pastel on Wallis sanded pastel paper
36" x 24" (91cm x 61cm)

THE SKY REFLECTED

This is a fascinating image of an old abandoned mill complex just outside Bozeman, MT. Each angle reveals rich painting opportunities. This particular view allowed me to play with an abstract composition based upon the rule of thirds. The verticals and horizontals break the painting into thirds, with the overlying shadows and reflections providing wonderful plaid-like transparencies to play with—what fun!

Materials

1 DRAW CAREFULLY

Some paintings require more care when doing the initial drawing, and this is one of those paintings. Since the abstract qualities are as much a focus as the landscape elements, make sure the linework is straight and properly placed. Corrections are easy to make at this point.

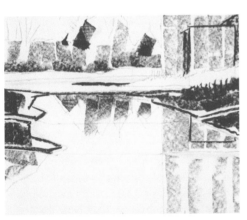

COLORS

Light value: warm white, cobalt blue, ultramarine blue, turquoise blue, warm beige, peach, warm green, cool green, yellow ochre, warm gray, gray

Midvalue: warm white, gray-blue, warm purple, teal gray, warm green, yellow ochre, gray-green, gray-purple, gray turquoise blue

Dark value: warm purple, cool purple, warm green, cool green, blue-gray, gray turquoise-blue, yellow ochre

2 SIMPLIFY THE UNDERPAINTING

Simplify the underpainting, staying away from any complexities in color, and focus instead on developing an accurate monochromatic base. Use a dark- to midvalue warm brown, just one pastel, to add some warmth, which will complement the cool final colors. Vary how strongly you apply this, which can create the different value shapes you'll want.

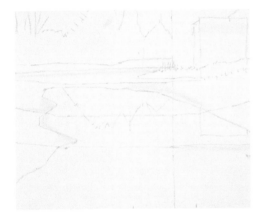

3 WASH DOWN THE PAINTING

Start with the darks, locking in their shapes. Keep your eye on the value relationships as you define the shapes. The lightest areas of sky and road can be toned using residual pigment left on your brush. Using this residual pastel, indicate where the shadow lies across the puddle. Make sure that the reflected shapes of the trees in the puddle line up directly under their source above. Let dry thoroughly before continuing.

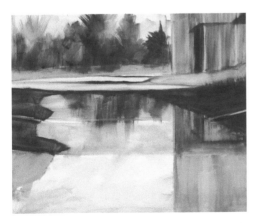

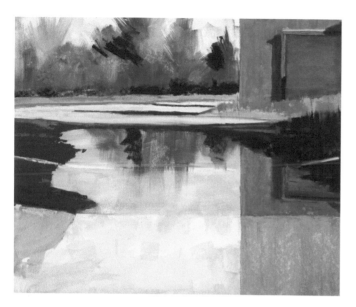

4 EVALUATE VALUE RELATIONSHIPS

The lightest value is on the road above the puddle, which contrasts against the dark shadows, giving the impression of bright sunshine. For the barn, use a combination of mid- and dark values of gray-green, warm gray-purple, and gray-blue. Use the same colors in the reflection. To darken the road, use dark value warm purple and gray-turquoise-blue. Boost the dark foliage shadowed areas with a dark warm green and then place the same color around the doorway, and grasses in shadow below the door.

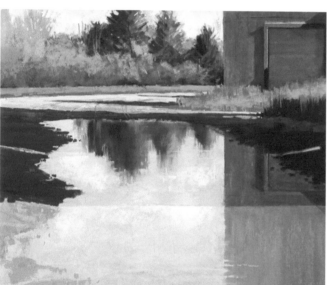

5 WORK THE SKY AND GREENS

The sky is farthest away, so this will be the first area to work toward finish. Gradiate the sky from lighter at the horizon to darker above, reversing it in the reflection so the darker sky is at the bottom. Develop the shapes of the trees and hedges in the background. Use the same colors on the same sky and green shapes in the water, softening and degrading the reflection as the puddle moves closer to you.

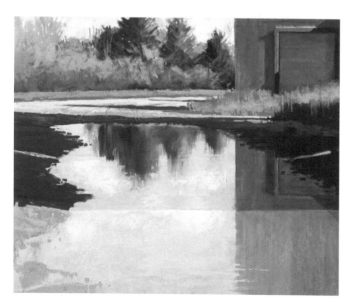

6 TIGHTEN THE BUILDING

Focus on the building. It doesn't hurt to pull out a ruler and measure, making sure edges are straight. Even being off a 1/16" (2mm) can be obvious. Note that the reflection of the building in the shadow is actually darker than the building itself. And even though it is a reflection on calm water, the image is degrading so edges are not as distinct. Once you finish the building, pick up your darkest dark—a dark value purple—and place some rocks and gravel over the reflection.

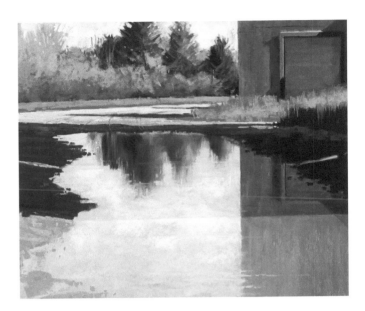

7 FINISH SKY REFLECTION IN PUDDLE

Using your pastels on the side, finish the sky and clouds in the puddle. Take your lightest value white and work on the clouds below the horizontal shadow. Choose a slightly darker light value warm white for the clouds in the shadow area.

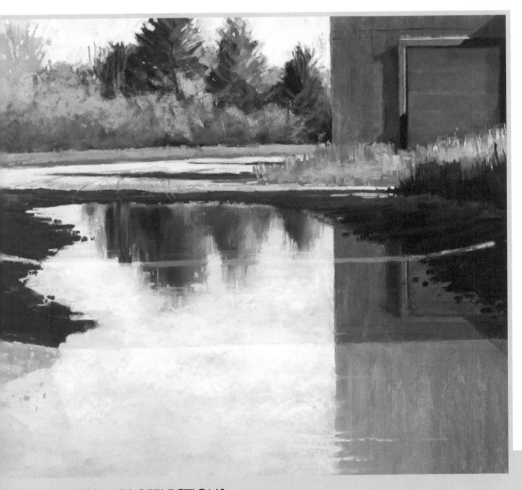

8 SUNLIGHT STREAK ACROSS PUDDLE

All your hard work has led to this final touch, placing the light streak across the puddle in the middle of the painting. This is not a simple case of picking up one light pastel and running it across the painting. First, get a ruler and measure a line that is straight across using light value gray. Follow this line and expand it with final colors to be about ³⁄₁₆" (5mm) wide. Choose your colors by imagining you are dropping a warm light over the existing colors. The streak over the gray building goes a lighter and warmer gray, over the trees goes lighter and warmer green, and over the sky goes lighter blue. A final adjustment to the bottom left of the painting to open up the puddle eliminates some unnecessary, eye-stopping detail and it's done.

STORY MILL REFLECTIONS
Pastel on UART #500 sanded pastel paper
20" x 24" (51cm x 61cm)

WATER IN THE SKY

Rainy days have a closer value range with more emphasis on the midvalues, hence the term "gray days." Moisture in the sky provides an artist with opportunities to manipulate the mood of an artwork. Rainy day depictions can range emotionally from dark and foreboding to more contemplative, subtle and quiet.

DULL DOWN YOUR VALUES

A wonderful way to achieve a dull, rainy look is to work on a darker surface, which will bring your highlights down. This technique was used in *Day Off*, which depicts a Maine fishing boat moored in a harbor on a rainy day. Rain has darkened features of the boat, almost blackening them, and has pulled a gray haze down over the background. The vertical strokes of pastel suggest the downward movement of rain.

RAPIDLY CHANGING CONDITIONS

Thunderstorms move quickly and are temporary compared to thoroughly rainy days. Generally occurring later in the day, thunderstorms are violent and can be accompanied by dramatic lighting as the storms pass through and late day lighting combines with dark clouds and wet surfaces.

DAY OFF
Pastel on black Canson Mi-Tientes paper
16" x 16" (41cm x 41cm)

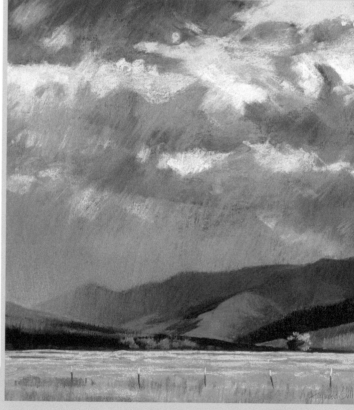

TAOS MOUNTAIN VALLEY
Pastel on Wallis sanded pastel paper
16" x 16" (41cm x 41cm)

PAINTING RAIN

Rainy days not only have a narrower range of values, but the lack of light will lend a monochromatic feel to your painting. The hallmarks of rainy paintings are the reflections created. You can turn a gray day into a rainy day without indicating a single falling raindrop—just make a surface, like a road, reflective.

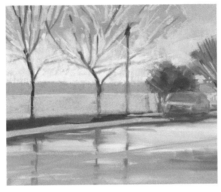

Materials

COLORS

Light value: warm gray, warm gray-purple, warm yellow, cool gray, warm and cool white

Midvalue: warm gray, warm gray-purple, warm green, warm yellow, cool gray

Dark value: warm purple, warm green, warm gray, warm gray-purple

1 CREATE THE UNDERPAINTING

Use a combination of gray-purples and grays to establish the basic shapes and values. Wash it down with your solvent of choice. Using a wet brush, pick up some dark warm purple and draw in the thin tree gestures.

2 DEVELOP BACKGROUND

With mid- and light-value warm gray-purples and grays, establish the big value shapes in the background. Since you are painting rain, the values will be close together and there will be no detail or discernable color on the far shore. Use your pastel on the side to create negative space tree branches. Make sure the sky value transitions upwards consistently, light to dark behind the trees.

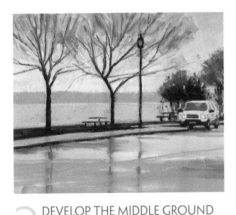

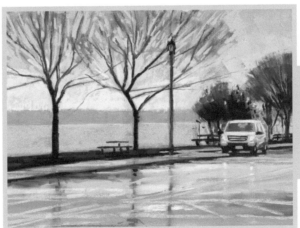

CANANDAIGUA MUSINGS
Pastel on UART #500 sanded pastel paper
12" x 18" (31cm x 46cm)

3 DEVELOP THE MIDDLE GROUND

Draw in the major tree branches with dark warm purple. Lighten your value as you draw the smaller branches. Use a dark warm green on the grass and tree behind the car.

Develop the car, placing the brightest bright, a light value warm yellow, in the headlights.

4 FINISH FOREGROUND AND REFLECTIONS

Draw in the diagonal yellow road stripes and the lighter crosswalk markings. Do both with a light hand, making these lines translucent so the pavement color shows through. Use a light value gray-purple for reflected highlights, a midvalue gray purple for the reflected trees, branches and lightpole. Place the warm light reflection of the headlights, sharper closer to the car and fading out further down.

EMBRACE THE HAZE

The use of fog and haze in paintings is an integral tool in taking a flat surface and making it appear three-dimensional. Creating distance is achieved by placing a blue or purplish haze of atmosphere over background elements, eliminating detail and connecting it to the sky by the color used. Atmosphere can be used to direct your eye and create different moods in your paintings. *First Snow, Bridger's* has a grand vista, with the foreground downplayed and the light on the distant mountains drawing your eye. Using a veil of haze gives you the sense of distance, revealing layers of mountains but still muting colors and distant details. In *Tennessee Morn*, the focus is on the farm, so the extreme haze is used to keep your eye from wandering off the focal point, creating a more intimate portrait.

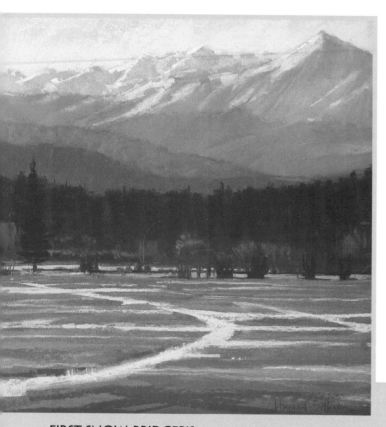

FIRST SNOW, BRIDGER'S
Pastel on UART #500 sanded pastel paper
16" x 16" (41cm x 41cm)

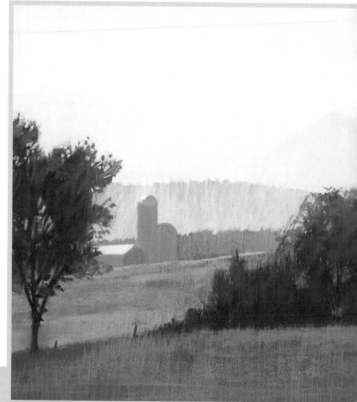

TENNESSEE MORN
Pastel on Wallis sanded pastel paper
16" x 16" (41cm x 41cm)

PAINTING FOG

Painting fog requires a light hand in layering atmosphere down over a prepared subject. This is a good time to play with impressionistic techniques. Try leaving visible marks and, instead of relying on grays, choose same value colors, interweaving them over each other. Using a midvalue toned paper will go a long way in establishing the painting's predominant value. Only in the very foreground will the values go a bit darker. This painting is all about developing the lighter values of the mist itself.

1 LAY IN BIG SHAPES
Choose a light-value gray-purple to draw in the big shapes. Then using the same pastel on its side, put down the first layer of pastel, defining the big, light shapes of the painting.

2 DEVELOP VALUES OF DARKER SHAPES
Use midvalue and darker value warm gray-greens to develop the land masses and the distant trees, which are darker in value than the paper. Use broad strokes on the side of your pastel so this layer goes down lightly and doesn't fill in the paper's tooth. Make the foreground darker, fading to lighter land areas in the background.

3 WORK INTO THE HAZE
Build up some same-value colors in the big shapes. Use midvalue yellows and yellow-green in the marsh. In the sky, use light values of pink, lavender and beige. Take the light-value sky colors and work the haze down over them, leaving spots of midvalue showing through. Carefully observe slight value changes. The dominant color of the haze is lavender. Remember, the most distant objects will have the softest edges and the least amount of detail.

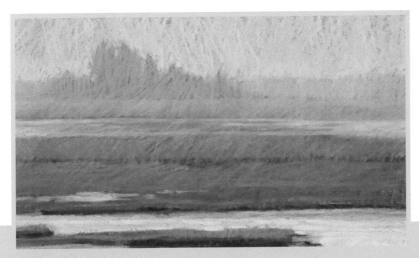

4 COMING INTO FOCUS
As you move down the painting, keep bringing the purple haze down over the green marsh. As you move towards the base, your haze value will darken and more of the local color will show through. When you reach the bottom quarter of the painting, objects sharpen as edges come more into focus and contrast increases since you are looking through less haze.

PURPLE HAZE
Pastel on Wallis Belgium Mist sanded pastel paper
18" x 10" (46cm x 25cm)

WATER IN WINTER

Winter is one of my favorite subjects to paint. Trees shed leaves, exposing their skeletal gestures. Shadows are long and dramatic even at midday. And the color of snow is always fascinating, ranging from pale pinks and peaches to deep indigo, cobalt and purple. Draping the landscape in white is like dropping a blank canvas over the land, revealing the pitch of landforms and making it easier for an artist to see reflected and cast light.

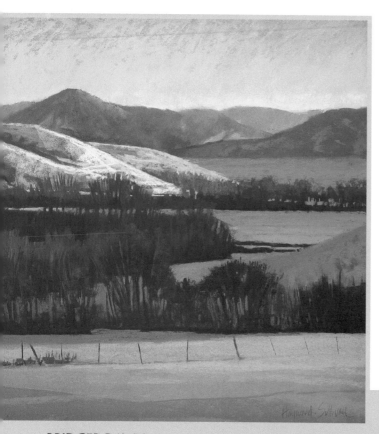

BRIDGER DAWN
Pastel on UART 500 sanded pastel paper
16" x 16" (41cm x 41cm)

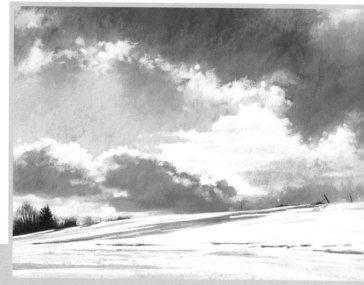

WINTER BLOW
Pastel on Wallis sanded pastel paper
24" x 36" (61cm x 91cm)

PAINTING SNOW

One of the reasons I paint in pastel is because it allows me to build a painting from dark to light. To fully appreciate the experience, I generally start a snow painting on a dark, often black, ground. This way I can actually build the painting by laying snow down over my painting as if it is falling from the sky.

Materials

Vine charcoal

Light value: warm and cool gray, ultramarine blue, warm and cool white

Midvalue: yellow ochre, warm and cool gray, ultramarine blue, cobalt blue, brown

Dark value: yellow ochre, brown, warm and cool gray, warm purple

 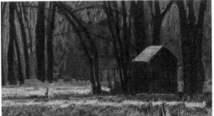

1 PREPARE YOUR BASE

Start by identifying the primary big shapes. On dark paper, you will want to thoughtfully build up the lights because it is hard to reestablish a darker value. Use a neutral, light-value gray to place the shape of the snow in the lower third. Do not place it solidly or cover over areas where dead grasses will poke through. Using a dark-value brown, place the shape of the cabin and major tree trunks in the midground.

2 BACKGROUND

Use two or three hues of mid- to dark-value grays and develop the background. Use a piece of vine charcoal to help define the trees, with the grays going into the negative space around the trunks.

3 ADD SOME COLOR

Pick up some intense midvalue to light-value ultramarine blues to fine tune your values. The shed roof is a darker value than the snow on the flat surfaces. Bring in a little midvalue yellow ochre for touches of warmth in the grasses. Use the vine charcoal to indicate overhanging small branches. Vary the line width as you draw, giving the feel of tangled branches. Using a thin pastel in the same ultramarine value as the shed roof, pick out a few of the branches and place some snow on top.

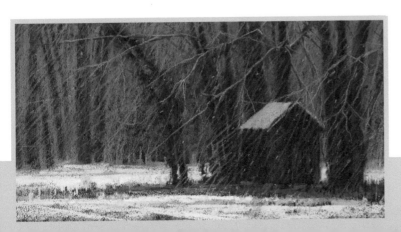

4 BRING ON THE STORM!!

Use the thin ultramarine blue you used for the tree branch snow and draw thin, light lines going at the same angle over the dark areas of the painting to indicate falling snow. The lines can cross at oblique angles but draw thinking of how snow falls during a storm. Make some small dots with the same pastel to depict a few individual snowflakes.

SHELTER FROM THE STORM
Pastel on Canson Mi-Tientes, Stygian black
9" x 18" (23cm x 46cm)

THE COLOR OF SNOW

My very favorite subject to paint is snow in shadow. The colors are astounding as the snow reflects the color of the sky above, and pastels have the brilliant pigments that depict it so well. Snow shadows are actually closer to gray in midday when the sky is lighter. The lower the angle of the sun at sunrise and sunset, the darker the sky, and this is the color that is cast down into shadowed areas to create blues, turquoise, indigos and sometimes purples.

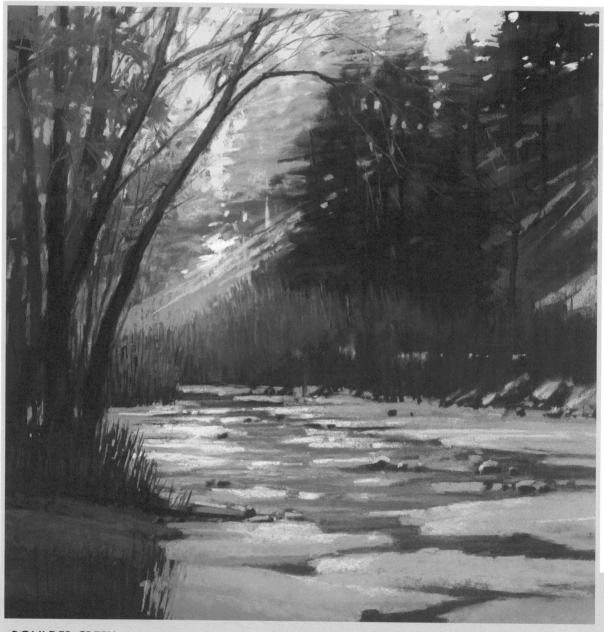

BOULDER CREEK
Pastel on UART #500 sanded pastel paper
20" x 20" (51cm x 51cm)

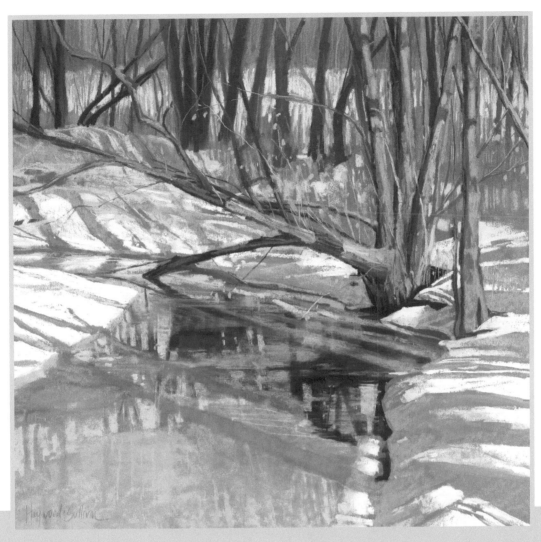

WINTER CREEK
Pastel on Wallis sanded pastel paper
24" x 24" (61cm x 61cm)

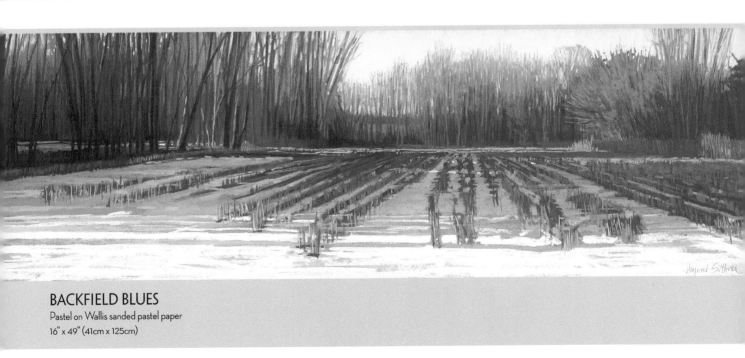

BACKFIELD BLUES
Pastel on Wallis sanded pastel paper
16" x 49" (41cm x 125cm)

PAINTING TREES AGAINST THE SKY

This is always a popular subject with my students. The transition from tree to sky requires some practice and a sensitive touch to make it believable. Attention to value is important, and I suggest using a push-and-pull technique where you first work the tree, then pull sky holes through, repeating until it looks right.

CHANGE YOUR TREE TRUNK VALUE

The biggest mistake artists make when painting trees is choosing a color for the trunk and maintaining the same color and value from the bottom to the top of the tree. When painting a leafless tree, the trunk should be darkest towards the base where there is less ambient light. As you move up the trunk, the branches get lighter because they are surrounded by more light. The uppermost branches will be several values lighter because they receive the most direct light. If you use the same value as at the base, then the top branches will be too dark and look like they were pasted onto the painting.

TREES ARE VOLUMES

Another important concept to remember is that you want to make your trees look volumetric. Since trees are round, the values on the trunk will vary between the two edges and the center, depending upon the direction of the light. You flatten your painting when your tree trunks are the same flat value from one edge to the other.

FOLIAGE AGAINST THE SKY

When placing leaves on the upper branches of a tree, carefully evaluate the value of the foliage against the sky and the direction of the light. Typical daylight lighting has the value of the tree and leaves darker than the surrounding sky. However, depending on your viewpoint, the time of day and weather conditions, the foliage value could be the same as the sky, creating a lost and found edge. Trees can also be lighter than the background sky as in *Margarita Light*, which has both lighter trees and lost and found foliage due to the stormy background sky.

TRACTOR PATH
Pastel on UART #500 sanded pastel paper
20" x 20" (51cm x 51cm)

MARGARITA LIGHT
Pastel on UART #500 sanded pastel paper
15" x 30" (38cm x 76cm)

SKYLIGHT ON TREE TRUNK

This right and wrong step-by-step comparison demonstrates how light from the sky affects the color and value of a tree base. The trees on the left are completed from start to finish using one dark brown pastel with no variation in value. The trees on the right are produced using four values of the same color brown.

DON'T

DO

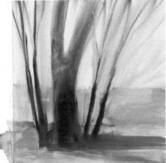

1 UNDERPAINTING

In the underpainting phase, the value of the main trunk and smaller side trees on the left is the same dark-value brown. The painting on the right uses the same dark brown pastel at the base but the pastel lightens as the tree moves up against the sky. Smaller trees are treated the same way, with smaller branches indicated using brushstokes containing leftover washed down pastel.

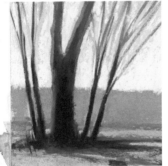

2 DEVELOP BACKGROUND AND TREE TRUNKS

The trees on the left continue to be developed using the same dark brown pastel over their entire length. The trees on the right are now using three values of the same brown: dark, middle and middle light. The dark-value is limited to the tree trunks below the hill in the back. The middle value is used for the smaller tree trunks above the hill. The middle light is used for the smallest tree branches and the value of the tree side facing the sun.

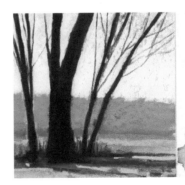
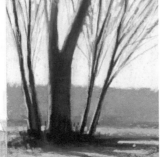

3 LOOKING FOR THE LIGHT

Smaller branches have been added to the trees on the left, using the same value dark brown pastel. The result is that the tree has little relationship to its background. On the right, smaller branches are applied using the middle light and a light-value brown.

The last touch is to apply cast light that is being bounced up from the green grass. Use a darker value of the warm grass green to apply to the lower area of the trunk. Finally, the very upper trunk actually picks up a slight reflected blue cast from the blue sky.

A CROWN OF TREES AGAINST THE SKY

This underpainting technique eliminates the white spots and uneven sky transition that can occur when you try to paint the top of trees against the sky.

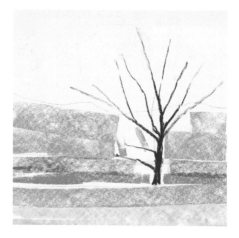

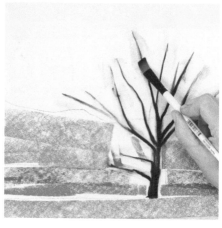

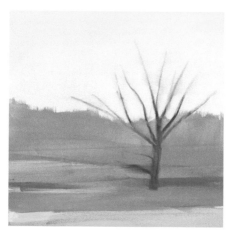

1 DRAW THE TREE

Use a dark-value brown to draw in the trunk and main branches. Get the gesture, the movement and direction of the tree. Primary branches do not extend all the way out to the edge of the crown. Vary your line weight so the branches get thinner and lighter as they move away from the trunk.

Place your other underpainting colors so that they come close to the tree but do not touch it.

2 WASH DOWN TREE

Using a clean brush, start at the top of each branch and wash it down moving inwards towards the trunk. Clean your brush after each stroke. Doing it this way maintains the thinning line. If you start at the trunk and move outwards, the brush carries additional pastel with it and your outer branches will get too thick.

Let dry thoroughly.

3 WASH DOWN THE BACKGROUND

Starting with the sky, wash down the rest of the painting. Go right over the branches and trunk of the tree. You want to get the sky evenly behind the tree branches, so by moving the brush sideways, you will get the proper transition from light to darker in the sky. Your tree will look ghosted, but you have captured the gesture and have a template to guide your hand when repainting it.

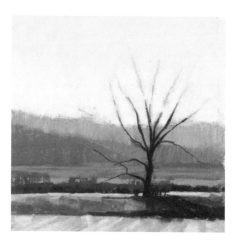

4 DEVELOP THE PAINTING

Place the sky in, working around the ghosted branches of the tree. Develop the rest of the painting and then reestablish the darker value of the tree. Re-draw the main branches using a dark-value brown but do not take this dark brown up into the sky above the mountain where it will be too dark.

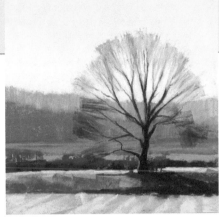

5 ESTABLISH UPPER BRANCHES

Using mid- and light-value brown pastels with a sharp edge (harder pastels work better here), lightly indicate the branches against the sky. The thinner the branch, the lighter the value. With your pastel on the side, pull swathes of transparent color in towards the tree center. These indicate the tiny branches you do not want to draw individually.

6 PUSH AND PULL TO FINISH UPPER TREE

To fine-tune the upper tiny branches against the sky, retrieve the sky colors and work in some sky holes. Break up the upper edge of the wide strokes so they are more uneven. Reestablish the larger branches as necessary.

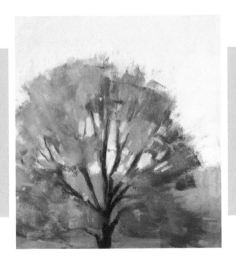

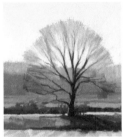

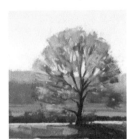

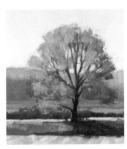

Sky Holes

Sky holes are the openings in the crown of the tree that allow the sky to show through. Sky holes are placed towards the end and should be used sparingly. When well placed, they assist in the relationship of the tree to the sky. If you haven't established the skeleton of the tree, you can use sky holes to give indication of hidden branches by painting the negative space (the sky) around the branch. The general rule of thumb is to use a value of pastel that is a value darker than the surrounding sky, because the light is actually passing through leaves and branches, which dull down the brightness of the light.

Adding Seasonal Foliage

An interesting way to paint trees is to start with the skeleton and then apply the leaves. This is the way I recommend to paint spring since new leaves appear translucent and much of the structure of the tree remains visible. Here, I take the winter tree in the previous exercise and add a thin draping of green to indicate spring, then to full summer foliage and into colorful fall. Keep an eye on the direction of light to determine your darker shadowed areas and lighter sunlit ones. Reestablish tree branches and sky holes as necessary. Notice how the transitions are very minimal, mostly a change in color, not the addition of heavy dense leaves. Use a light hand and keep the foliage translucent. In the end, the character of the tree is never lost.

CONCLUSION

To paint is like running down a rock-laden stream, leaping from stone to stone, your eye aimed on the next rock before even landing on the rock directly underfoot, eye and brain always focused one step ahead. This is being in the zone, my favorite place to be, with my eye on the next stroke while my hand is executing the current one with all the knowledge and lessons gained through the years—it's like having a toned body that allows you to leap down the stream. You trust that your skill is there, supporting every move you make, but you are not consciously thinking about it. When you are in this zone, the world doesn't exist. The act of creation just flows and takes you along.

Having worked this way for years, it was somewhat of a challenge to change methodologies to write this book. I had to slow down and document each step along the way to create the numerous step-by-step demos sprinkled throughout this book. Paint, stop, evaluate, shoot, write, paint, etc... Although initially laborious, this method eventually became much easier as my brain altered its way of approaching a painting. I could anticipate the logical breaks and the process began to flow. And then something else happened: Because I brought the aspect of conscious thinking back into my painting, my paintings got better.

This doesn't mean that I will document the steps of every painting I do from this point forward, but it does reinforce a very powerful lesson. Shake things up. Challenge yourself, consciously and consistently. Take a painting concept that you discarded because it didn't feel right to you and try it again. You are a different artist now than you were before. You have more experience and perhaps a technique was previously revealed to you before you were ready, but you might be ready now. Your brain is very plastic, it can stretch and grow and move in ways you haven't even tried. You might not always find the right teacher, but you can teach yourself.

To that end, I hope that this book offers you some new insights, and inspires you to reach for new challenges in your artwork.

Happy Painting!
liz Haywood-Sullivan

FANFARE ▷
Pastel on UART #500 sanded pastel paper
24" x 24" (61cm x 61cm)

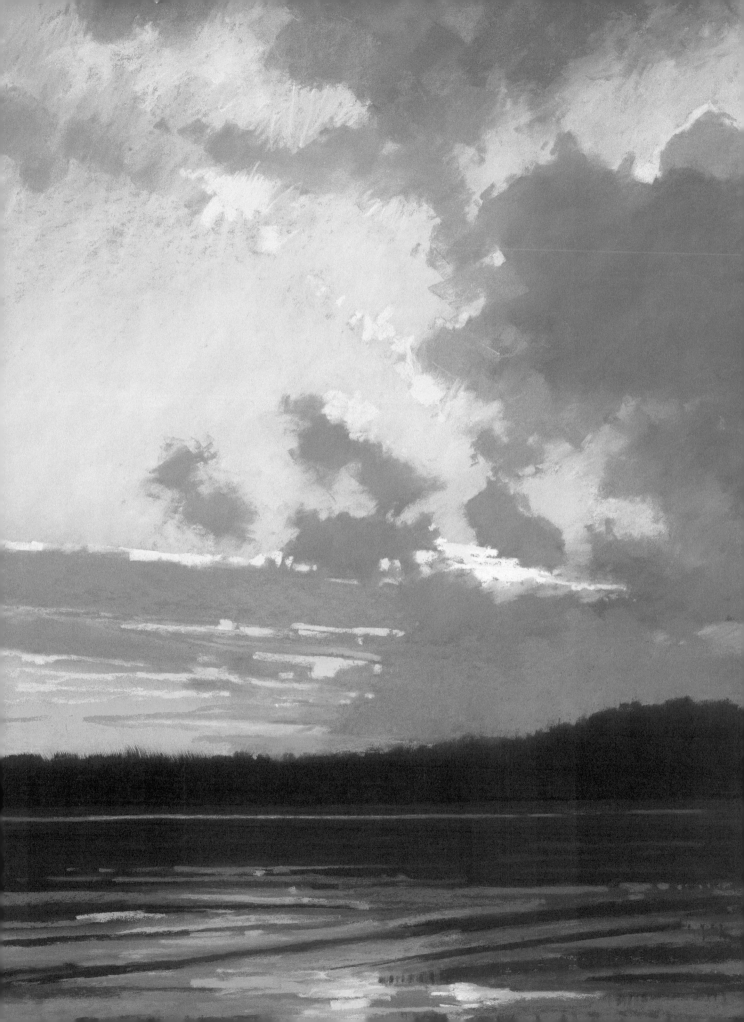

INDEX

ABOUT THE AUTHOR

Liz Haywood-Sullivan began drawing as a child in a creative family, and in 1996 after a twenty-year career in exhibit design, graphic design and illustration, she returned to her early roots in the fine arts. Choosing pastel, she has dedicated herself to the medium. Her paintings have appeared in numerous publications, museum shows and are sought after by collectors.

Dedicated to education in the arts, she shares her love of pastel with students in classes and workshops she teaches nationally and internationally. Her dedication has led her to work with the International Association of Pastel Societies, where she is vice president and also represents the organization at ASTM (the American Society of Testing and Materials) meetings, where they are currently working on a lightfastness standard for pastel. A Signature member of the Pastel Society of America since 1998, she holds Signature memberships in the Connecticut Pastel Society and the Pastel Painters Society of Cape Cod, as well as memberships in the Salmagundi Club of New York and Academic Artists Association. Her paintings have appeared in *Painting Sunlight and Shadow with Pastel* (Price, 2011) and *Art Journey America: Landscapes* (F+W Media, Inc., 2011). In 2012, she made three DVDs, released by The Artist's Network, on painting realistic skies, water and greens. Her representation includes Vose Galleries of Boston and Montana Trails Gallery in Bozeman, Montana. She can be contacted at liz@haywood-sullivan.com or lizhaywoodsullivan.com.

Other fine North Light Books are available from your favorite bookstore, art supply store or online supplier. Visit our website at fwmedia.com.

17 16 15 14 13 5 4 3 2 1

DISTRIBUTED IN CANADA BY FRASER DIRECT
100 Armstrong Avenue
Georgetown, ON, Canada L7G 5S4
Tel: (905) 877-4411

DISTRIBUTED IN THE U.K. AND EUROPE
BY F&W MEDIA INTERNATIONAL, LTD
Brunel House, Forde Close, Newton Abbot, TQ12 4PU, UK
Tel: (+44) 1626 323200, Fax: (+44) 1626 323319
Email: enquiries@fwmedia.com

DISTRIBUTED IN AUSTRALIA BY CAPRICORN LINK
P.O. Box 704, S. Windsor NSW, 2756 Australia
Tel: 02 4560 1600, Fax: 02 4577 5288
Email: books@capricornlink.com.au

Edited by: Vanessa Wieland
Designed by: Kelly O'Dell
Production Edited by: Mark Griffin

Metric Conversion Chart

TO CONVERT	TO	MULTIPLY BY
Inches	Centimeters	2.54
Centimeters	Inches	0.4
Feet	Centimeters	30.5
Centimeters	Feet	0.03
Yards	Meters	0.9
Meters	Yards	1.1

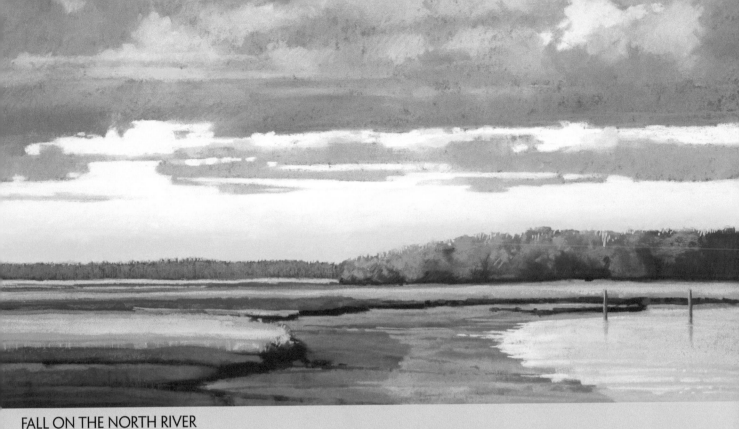

FALL ON THE NORTH RIVER
Pastel on UART 500 sanded pastel paper
24" x 36" (61cm x 91cm)

ACKNOWLEDGMENTS

To start at the beginning, I wish to thank my parents, Maryanne and Bill Haywood, whose encouragement of my artistic talents started the day I was born and continue to this day. For my inspiring daughter, Meg Haywood-Sullivan, who continues the family creative legacy with her brilliant photography. And the Sullivan family, lead by Jack and Joan, who welcomed me in and became some of my greatest supporters.

For Tom O'Brien, my high school art teacher, for gently nudging me in the right direction when it was needed and for the best design education a fine artist could desire at the Rochester Institute of Technology.

This book would not have happened without photographic assistance from my husband, Michael, encouragement from my fellow artist, friend and author Maggie Price, and the support of the dedicated people at F+W Media, especially Jamie Markle and my editor, Vanessa Wieland, who gave me the opportunity to bring my book dreams to life.

Artists cannot create without our tools and I want to recognize the historical and contemporary masters of pigment and paper who make our art possible. In particular I wish to thank Terry Ludwig for his humor and his dedication to the pastel medium.

Finally, to North River Arts Society, which opened so many doors for me, including the challenge of teaching, and to all my students for allowing me to try out ideas on them, never knowing that I received as much from them as they did from me. To Donna Rossetti-Bailey, my best cheerleader and friend. And to the International Association of Pastel Societies and all the numerous pastel societies for their support of this brilliant medium of pastel and of all the artists like myself, that find themselves under its spell.

DEDICATION

I dedicate this book to my husband, Michael Sullivan. For your love and unwavering support of my artistic journey. You, your genius and photography continue to hold me spellbound.

IDEAS. INSTRUCTION. INSPIRATION.

Receive FREE downloadable bonus materials when you sign up for our free newsletter at artistsnetwork.com/Newsletter_Thanks.

PAINTING
sunlight
& shadow
WITH PASTELS

essential techniques
for brilliant effects

Maggie Price

MAKING A SCENE: THREE UNIQUE PERSPECTIVES ON PAINTING THE LANDSCAPE

Pastel JOURNAL
your ultimate creative resource

Portrait Demonstration:
Capture Character in 7 Steps

Limit Your Palette and
Expand Your Color Expertise

Live a Creative Life: Become
an Artist-in-Residence

www.pasteljournal.com

Find the latest issues of
Pastel Journal on newsstands,
or visit artistsnetwork.com.

These and other fine North Light products
are available at your favorite art & craft
retailer, bookstore or online supplier. Visit
our websites at *artistsnetwork.com* and
artistsnetwork.tv.

Follow North Light Books
for the latest news, free
wallpapers, free demos and
chances to win FREE BOOKS!

VISIT ARTISTSNETWORK.COM AND GET JEN'S NORTH LIGHT PICKS!

Get free step-by-step demonstrations along with
reviews of the latest books, videos and downloads
from Jennifer Lepore, Senior Editor and Online
Education Manager at North Light Books.

GET INVOLVED
Learn from the experts. Join the conversation on

128